BARRON'S ART HANDBOOKS

MIXING COLORS
3. DRY TECHNIQUES

BARRON'S ART HANDBOOKS

MIXING COLORS
3. DRY TECHNIQUES

BARRON'S

CONTENTS

CONTENTS

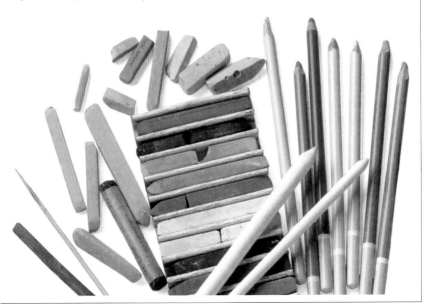

COLOR THEORY

Light

Thanks to the investigations of scientists such as Newton and Young we have been able to establish, based upon the composition of white light, its behavior as it applies to wave theory.

Color cannot be perceived in total darkness. With just a minimum amount of light the eye begins to discern colors. Depending on the quality and the intensity of the light, the coloration of an object will have different characteristics.

White light is composed of multiple parts of different colors. The basic, or primary colors, of light are green, red, and deep blue.

The coloration of an object is dependent on the principles of absorption and reflection of light. White objects reflect all of the colors. Black objects absorb all of the colors. Gray objects reflect and absorb equal amounts of red, green, and blue. Yellow objects absorb the blue and reflect the red and green. Magenta colored objects reflect the blue and red and absorb the green. A blue surface absorbs the red and reflects

Illustration of the principle of absorption and reflection of light.

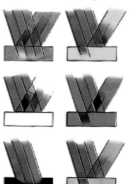

the blue and green. See the illustrations of this principle.

Additive Combinations

Again, white light is composed of multiple parts of light of different colors. The basic, or primary, colors of light are green, red, and deep blue. Superimposing two primary light colors gives us the secondary light colors. Thus, the superimposition of green and red light gives us yellow. By superimposing red and dark blue light, magenta is obtained. Superimposing dark blue and green light produces cyan, a greenish blue. The superimposition of dark colors of light results in a lighter color. All three primary colors superimposed give us white light, the lightest of all.

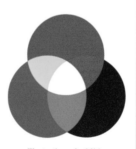

Illustration of additive combinations.

Subtractive Combinations

Painters work with pigment colors. A pigment color is a pigment mixed with a medium that will give it body and consistency. It is the media and their solvents that give their names to paint, for example: oils, watercolor, acrylics, etc. A pigment color, depending on its medium, will produce transparent, semi-transparent, or opaque effects.

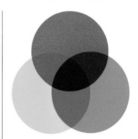

Illustration of subtractive combinations.

By mixing from a palette made up of various pigments the artist can produce an infinite variety of colors. The color sytem offered here is one that uses primary colors that parallel those used in light mixture.

These basic or primary colors produce darker colors when mixed. This is known as subtractive mixing. The colors mixed have less and less light and are seen to get darker and darker.

Black is the result of mixing yellow, carmine, and light blue in equal parts. With yellow and carmine in equal parts we get red. Yellow mixed with the same amount of blue gives us green. By mixing carmine and light blue in equal proportions, we obtain a deep, dark purplish blue. Note the difference in the illustrations of both types of combination.

Primary, Secondary, and Tertiary Colors

According to the principle of subtractive color mixing the secondary colors are obtained by mixing two colors from the three primary colors, yellow, carmine, and light blue, in equal parts. Again, according to this color system, the three secondary colors are red, green, and dark (purplish) blue.

The tertiary colors are obtained by mixing, in equal

Secondaries (S)

Tertiaries (T)

Illustration of the formation of secondary and tertiary colors from the primary colors.

parts, a primary color (P) with the secondary color (S) that contains that primary color. Six tertiary colors can be formed. Blue-green is obtained from S green and P blue. Yellow-green is the result of mixing P yellow and S green. Orange is composed of P yellow and S red. Violet is mixed with S blue and P carmine. Crimson red is obtained from S red and P carmine. Violet blue requires S blue and P blue. The tertiary colors are represented by the letter T.

Complementary Colors

These are colors that offer maximum contrast when placed side by side. Yellow and deep blue are directly complementary. So are carmine and green, and red and light blue. You may observe by the illustration of subtractive mixtures that deep blue is complementary to yellow, which does not form part of its composition (since the S blue is obtained from P blue and P carmine). The other pairs of complementary colors also

follow this pattern. The illustration gives a clear picture of the way these complementary mixtures are made.

The color wheel, illustrated on page 8, shows the relationship of the primary, secondary, and tertiary colors, and indicates the composition. Complementary pairs appear directly opposite each other on the wheel.

MORE ON THIS TOPIC
· Harmonious ranges **p. 8**

Neutral Colors

Knowledge of the complementary nature of colors is necessary in order to evaluate contrasts, to study harmony in depth, and to produce clean neutral colors.

If the mixture of the three primary colors gives us black, then mixing equal parts of a primary color with the secondary that does not contain it, will also give us a very dark color that is almost black. Two complementary colors mixed in similar quantities produce dark, ill defined colors. But if we mix two complementary colors in very unequal proportions we get a grayish color tending toward the predominant color in the mixture. A neutral, or broken, color is defined as one that is obtained by mixing two complementary colors in unequal measures, and to which white may be added.

Complementary colors

The secondary deep blue is complementary to the primary yellow.

The secondary red is complementary to the primary blue.

The secondary green is complementary to the primary carmine.

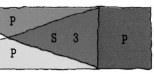

HARMONIOUS RANGES

Color, Temperature, and Psychological Association

There is a series of sensations associated with the sight of certain colors. Warm colors produce sensations of heat, proximity, and expansiveness. Cool colors, on the other hand, cause a feeling of coldness and distance.

The warm colors are those found between magenta and yellow, including their adjacent colors on the color wheel: carmine, reds, oranges, orange-yellows, yellows. Ochres, earth colors, some purples, and green-yellows are also warm colors.

The cool colors are the blues, blue-greens, greens, and those grays that have any of these cool colors as predominant ingredients. The coolness of a color diminishes as its intensity is lessened (by adding, say, white, gray, or the color's complement).

It is worth noting that neutral colors can show a marked tendency towards cool or warm, depending whether the predominant color in its composition is a warm color (or mixture) or a cool one.

A painting is a group of patches of color that the artist sees as a whole, and which finally have to be brought into harmonious relationship to one another. Harmonizing color means balancing and unifying

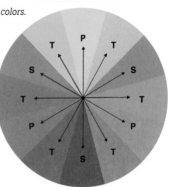

Color wheel for pigment colors. The color wheel is an illustration in which the primary, secondary, and tertiary colors appear. Note their order: a primary color is flanked by the two tertiaries it generates, and these in turn are next to the two secondaries that form them. Complementary colors are directly opposite one another.

colors within a composition and trying to obtain a whole that is pleasing to the eye. While color harmony may follow certain observable principles, its achievement is largely subjective and intuitive.

Color Ranges

Objects in a given subject have their own coloration that is influenced by the light they are seen in. Generally, they will suggest a dominant color. In order to explore colors for a given composition that will appear harmonious and unified as well as conveying a color mood, chromatic studies are useful. The three color wheels illustrated indicate some possibilities. A warm group, a cool group, and a harmonious group of neutrals.

Knowledge of such harmonious color groups can clarify your options and organize your palette as you approach painting a subject.

A range or gradation is any ordered succession of colors. A simple color gradation starts with a single color and is graded by tones using first black then white.

The simple harmonious range is based on a dominant color, its direct complement, and its neighboring colors on the color wheel.

Harmonious Ranges: Warm, Cold, Neutral

Obvious harmonious ranges are: The warm range (in which most of the colors are warm colors), the cold range (with a predominance of cool colors), and the neutral range (where the

Range of warm colors.

Range of cool colors.

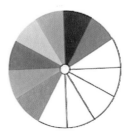

Range of neutral colors.

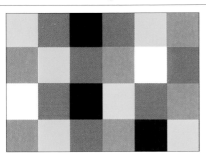

Contrasting colors.

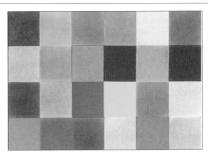

Contrasting ranges.

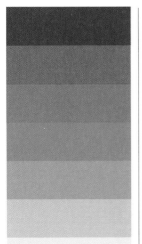

Contrasting shades.

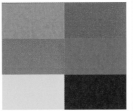

*Contrasting
complementary colors.*

*Simultaneous
contrasting of colors.*

majority show the grayish shades of the neutral colors). Neutral colors can be created by using pairs of complementary colors. The range of color each pair creates is produced by modifying the proportional contents of each in your mixtures.

Harmonizing and Contrasting

Harmonizing is finding the best visual relationship between all your colors. Contrast plays an important role.

Contrast can be between shades or colors. The principle of simultaneous contrast (an optical illusion) states that an intense color will appear darker when it is surrounded by another intense color that is lighter. Conversely, a color appears lighter if it is surrounded by a darker color. (See illustration.) In this way, color is seen to be easily manipulated. The same color may appear quite different, even within the same composi-tion, depending on the colors that are near it. Conversely, colors that in reality are quite different may be made to read as the same, again, depending on the colors that appear near them.

Maximum contrast is always that of two complementary colors at maximum intensity. Due to sensations that take place in the eye, one color will tend to visually cause its complementary color as an effect or afterimage. So color may be indirectly implied.

The phenomenon of afterimage with complementary colors. Remember that yellow and deep blue are complementary. After staring fixedly at the yellow background for 30 seconds, the gray square in the middle looks as if it has a bluish tinge, while the gray square on the blue background appears yellowish.

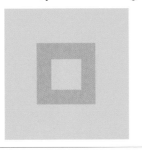

MORE ON THIS TOPIC

• Color theory **p. 6**

TONE EVALUATION

The System

Through tone evaluation a system of relationships is established between all the shades or degrees of light intensity within a composition. Tone evaluation in black and white is the simplest and at the same time the most fundamental way to understand value or light to shadow gradations.

Both the representation of volume and the differentiation between planes are based on a visual analysis that determines the different shades to be used. All the areas on which there falls the same intensity of light will be represented in the same general shade.

The initial sketches are usually done in charcoal, establishing three or four well-defined tonal areas, on a white piece of paper or support. The blank paper represents the maximum light intensity. Successive shading expresses one or two middle tones and a last darker one.

In the final work, the tone evaluation or sketch, done without jumps in tone, but rather by using gentle grading, can be considered an in-depth study of the chiaroscuro, or dark/light aspect of the subject.

Tone evaluation in practice.

The Path of Light

The process used to determine the tonal breakdown of a given subject takes observation of the path the light follows from its source to the shine it produces on the subject. The behavior of colors will be effected as objects and space pass from the half-light toward the shadows and darkness.

The route followed by light produces multiple reflections and refraction, depending on the characteristics of the bodies they illuminate. Each object will need to be represented as a gradation of tone as well as being represented in color. Building upon the tone analysis done in charcoal gradations of black, white, and gray will now need to be added to color to represent objects in all their gradations of light. Often a composition will break down into three or four areas of light intensity. Knowing this may help you locate and identify its tones.

The differences produced on the model are noticeable when the light changes.
The light shines from the front.

A view against the light.

Several Colors

Each object in a composition will take a gradation of tone and color to represent it. A wide range of tones will make for drama and interest in a composition, as well as engaging and satisfying the eye. Light is a determining factor in the representation of color. Some light is direct, some is reflected. Both will influence color and tone. Again, color representation requires understanding the tonal value as it combines with the coloration of the object or area. This establishes order

A landscape. If you look through half-closed eyes you can reduce the variety to basic areas of color.

The landscape showing its tones as a range of grays.

within a composition, one which corresponds to the black, white, gray charcoal study. Distance is also a determining factor in tone evaluation. There is greater definition and contrast in the foreground that gradually decreases toward the horizon.

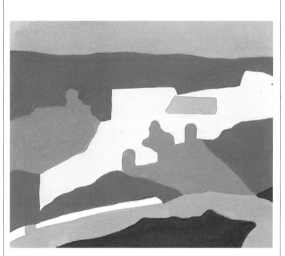

A graphic representation that shows the division into chromatic areas. Once these have been established, try to find evaluation of the tone in each of the areas of color.

MORE ON THIS TOPIC
· Charcoal **p. 22**
· Graphite pencils **p. 24**
· Sanguine crayons **p. 28**
· Sanguine pencils **p. 30**
· Transparent grading **p. 48**
· Grading **p. 50**

Chromatic reflections.
Colors that are near each other cause chromatic reflections that need to be represented.

DRY MEDIA

Introduction

Charcoal and Conté crayon, with touches of white chalk, have been used as drawing materials since the 16th century. In the 18th century there was an upsurge in the use of pastels and chalks, particularly in court portraits.

The characteristic shared by all dry media is that they contain no moist binders. Conté crayons (a somewhat waxy charcoal-like substance), Conté pencils, and lead or graphite pencils are all greasy media.

Charcoal

Charcoal is available in sticks of 5 to 6 inches long. Its diameter can be between 5 mm and 1.5 cm. These sticks are made from charred branches. Depending on the type of tree or bush, there can be up to three grades: soft, medium, or hard.

Charcoal pencils are derived from charcoal but contain binders to make them more substantial. There are also pencils made of Conté crayon. Both types of pencil have wooden encasements that can be carved away for purposes of sharpening. Each comes in various grades from hard to soft.

There are other variants of both charcoal and Conté pencils. In general, they contain charcoal or artificial charcoal to which clay and other binders have been added, to obtain a more stable medium. Also available on the market is powdered charcoal, which is very suitable for grisaille work, a form of working monochromatically. There are also sticks and crayons of artificial compressed charcoal and leads that can be used in mechanical pencils. With such a wide range of products, it is a good idea to experiment to get to know the properties of both the dry types and those that are somewhat greasier.

Sanguine

Sanguine is a pigment made from clay that contains iron oxide and hematite (iron peroxide). It is mixed with chalk.

It began to be used around the year 1500. Depending on the formula of its composition its color can vary from the characteristic rust (iron oxide), red, bister (yellowish-brown), sepia, and ochre.

Nowadays, sanguine is available in Conté crayon and Conté pencil forms.

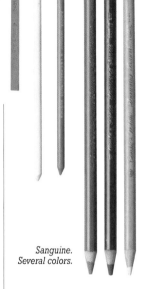

Sanguine.
Several colors.

Chalks and Pastels

Chalks and pastels are contemporaries of sanguine and white chalk in that they came into use at about the same time. White chalk was introduced in the 16th century as a highlighter for charcoal and sanguine drawings.

Chalk is a limestone substance, white or gray, which was formed in the Cretaceous period, from the skeletons of minute marine organisms rich in calcium. It is smooth in appearance, with a fine grain, and is very absorbent. At the end of the 17th century, chalk was available in sanguine color, dark sepia, black, gray ochre, and ultramarine blue.

Pastel colors, too, appeared at the beginning of the 16th century. This is a softer medium than chalk. Nowadays the extensive range of manufactured pastels includes soft and hard pastels and pastel pencils. The range of colored chalks, though

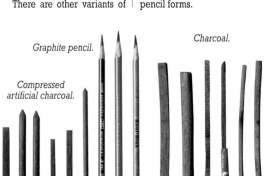

Graphite pencil.

Charcoal.

Compressed artificial charcoal.

not as wide as pastels, is still quite adequate for satisfying color representation. Some brands don't even distinguish between chalks and pastels.

Pastel is an agglutinated material obtained from mixing powdered pigment (as a coloring agent), gum arabic or tragacanth (as a binder), with a part of chalk (to obtain pale shades). Depending on their formula, pastels will be softer or harder. In the softer varieties the amount of binder is so small that the pastel could be considered pure pigment.

Dry Media Colors

Charcoal

The artist who usually uses charcoal for sketching and studying tone knows that not all charcoals shade in the same color. The brown or dark-gray tones are emphasized by blending strokes of different charcoals.

The black Conté pencil has a blue-black tone. Sticks of compressed artificial charcoal are quite dark yet look grayer than Conté pencil. Then, each brand has its own subtle

shades. These differences become obvious with experience.

Sanguine

Sanguine also comes in a range of colors. All brands offer several colors, which are generally: iron oxide red, sepia, sienna, and even ochre. There may be differences in shades of different brands.

Chalks and Pastels

All quality brands produce an extensive range of pastel colors. Colors vary from one manufacturer to another, and here color charts are helpful for distinguishing subtle differences.

The following two pages show a small selection as an example of the great variety of pastel colors available.

MORE ON THIS TOPIC

· Soft pastel colors **p. 14**

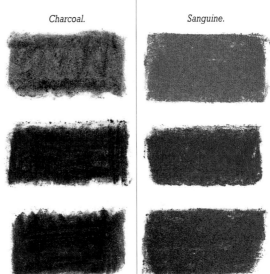

Charcoal.

Sanguine.

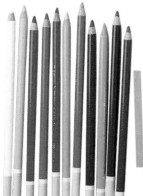

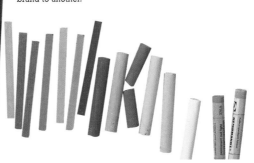

Chalks and pastels. A variety of pastel pencils, chalks, and soft pastels.
The size of the sticks (cross section for square ones and diameter for cylindrical ones) and their length may vary slightly from one brand to another.

SOFT PASTEL COLORS

Different manufacturers' color charts are useful tools as colors can be compared and cross-referenced to suit your needs. Individual sticks can usually be purchased separately.

Schminke Color Chart (280 colors)

+ Darker ⟵ Full color ⟶ + Lighter
B ⟵⟶ D ⟹ H ⟹ M ⟹ O

No.	Name / Pigment	Rating
002	Permanent yellow 1 lemon — Permanent azo dye	***
003	Permanent yellow 2 light — Permanent azo dye	***
004	Permanent yellow 3 dark — Permanent azo dye	***
005	Permanent orange 1 — Permanent azo dye	***
013	Light ochre — Iron oxide	*****
014	Golden ochre — Iron oxide	*****
016	Flesh ochre — Iron oxide	*****
017	Orange ochre — Iron oxide	*****
018	Burnt sienna — Iron oxide	*****
019	Bright burnt ochre — Iron oxide	*****
021	Pozzuoli brown — Iron oxide	*****
022	English red — Iron oxide	*****
023	Light caput nortum — Iron oxide	*****
024	Dark caput nortum — Iron oxide	*****
028	Light olive ochre — Iron oxide and chromium oxide	*****
029	Dark olive ochre — Iron oxide and chromium oxide	*****
030	Green umber — Iron oxide	*****
032	Dark ochre — Iron oxide	*****
033	Burnt green ochre — Iron oxide	*****
035	Burnt umber — Iron oxide	*****
036	Van Dyke brown — Iron oxide	*****
037	Sepia brown — Iron oxide	*****
042	Permanent red 1 light — Permanent azo dye	***
044	Permanent red 3 dark — Permanent azo dye	***
045	Ruby lake — Permanent azo dye	***
046	Carmine red — Permanent azo dye	***
047	Ruby pink — Permanent azo dye	***
099	Black — Permanent azo dye	*****

001 White ***** — Titanium oxide

Schminke Color Chart (continued)

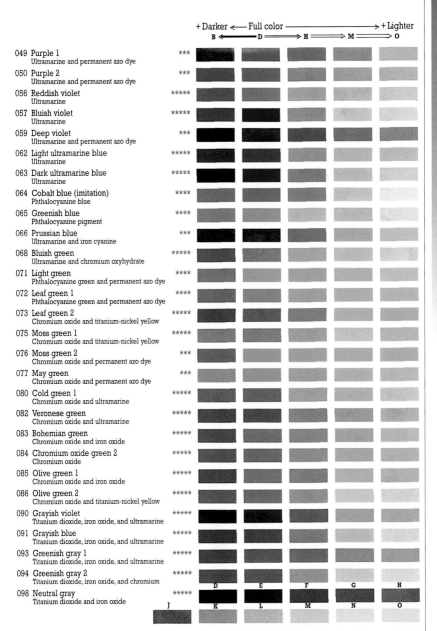

+ Darker ⟵ Full color ⟶ + Lighter
B ⟵ D ⟹ H ⟹ M ⟹ O

049 Purple 1 — ***
Ultramarine and permanent azo dye

050 Purple 2 — ***
Ultramarine and permanent azo dye

056 Reddish violet — *****
Ultramarine

057 Bluish violet — *****
Ultramarine

059 Deep violet — ***
Ultramarine and permanent azo dye

062 Light ultramarine blue — *****
Ultramarine

063 Dark ultramarine blue — *****
Ultramarine

064 Cobalt blue (imitation) — ****
Phthalocyanine blue

065 Greenish blue — ****
Phthalocyanine pigment

066 Prussian blue — ***
Ultramarine and iron cyanine

068 Bluish green — *****
Ultramarine and chromium oxyhydrate

071 Light green — ****
Phthalocyanine green and permanent azo dye

072 Leaf green 1 — ****
Phthalocyanine green and permanent azo dye

073 Leaf green 2 — *****
Chromium oxide and titanium-nickel yellow

075 Moss green 1 — *****
Chromium oxide and titanium-nickel yellow

076 Moss green 2 — ***
Chromium oxide and permanent azo dye

077 May green — ***
Chromium oxide and permanent azo dye

080 Cold green 1 — *****
Chromium oxide and ultramarine

082 Veronese green — *****
Chromium oxide and ultramarine

083 Bohemian green — *****
Chromium oxide and iron oxide

084 Chromium oxide green 2 — *****
Chromium oxide

085 Olive green 1 — *****
Chromium oxide and iron oxide

086 Olive green 2 — *****
Chromium oxide and titanium-nickel yellow

090 Grayish violet — *****
Titanium dioxide, iron oxide, and ultramarine

091 Grayish blue — *****
Titanium dioxide, iron oxide, and ultramarine

093 Greenish gray 1 — *****
Titanium dioxide, iron oxide, and ultramarine

094 Greenish gray 2 — *****
Titanium dioxide, iron oxide, and chromium

098 Neutral gray — *****
Titanium dioxide and iron oxide

Appearing on each line are the color darkened with black (B), dark (D), intermediate shades through mixing with white (H,M), and light (O).

Key to the symbols: ***** Maximum permanence of pigment (least subject to color change over time)
**** Very high permanence
*** Good degree of permanence
** Satisfactory permanence
* Sufficient permanence

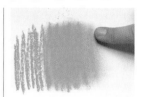

COMMON PROPERTIES

Blending

One common characteristic of all dry media is its blending capacity. Blending is the action of rubbing a cotton cloth, fingers, or paper stumps over a spot of color that has already been applied to the paper or the support.

The movement smudges the chalky particles of pigment. Blending allows you to soften and blur the outlines of the colored area, gradually reducing it to a fine film until it disappears into the color of the paper. Charcoal, sanguine, chalks, and pastels can be worked layer upon layer, particularly when using spray fixative. Hard pastels can be used to begin a composition, using blending. Soft pastels will nicely finish the work, bringing the pigment to higher brilliance and intensity.

Charcoal

Charcoal is very fragile and impermanent. Blending it requires a delicate touch. The image can be easily lost if it is not fixed. Sticks of compressed artificial charcoal or a Conté crayon or pencil adhere to the paper better but, because of

their binders, blending effects are less transparent, and they are difficult to erase. When mastered, however, they make for a rich medium.

Sanguine

Sanguine has very good adhesive properties; a rich gradation of tones can be

Blending the sanguine.

obtained using sanguine. Its look is softer than black. The forms it models can be a bridge to working in color, while it also possesses a beauty of its own.

Be careful not to press too hard on the paper, blocking in lightly. Gradually increase the intensity of the work by blocking in layers

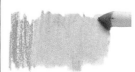

Blending with your finger.

Using a blending stick.

Blending with a piece of cotton. Lines are usually drawn with hard pastels while the soft pastels, which are much more fragile, are more suitable to use for blocking in.

Chalks and Pastels

The softer chalks and pastels are, the more workable they tend to be for blending. The color intensity and contrast value of soft pastels is unrivalled by other media. With harder pastels the effect of blending is quite different. Because of the higher chalk and lower pigment contents, the action of the chalk will dominate, making the colors appear muddy. This is an effect that, with practice, can be used to the advantage of the picture, particularly to offset the use of brighter, softer pigments. The process of working both chalks and pastels is one of layering, alternating

Blending charcoal.

MORE ON THIS TOPIC

- Charcoal **p. 22**
- Sanguine crayons **p. 28**
- Chalks and pastels **p. 40**

blending with blocking in fresh color, as well as using line. Fading softens a smudge of color or line, toning down an undesired contrast. The use of fixative will allow the artist to work layer upon layer.

Different color effects will be achieved by layering, depending on the order of your colors. Working from light to dark will tend to give a light airy look to the color, while working from dark to light lends a darker, more atmospheric mood. Pastel is as effective a medium for the representation of form as is oil color. Using your fingers to work and blend the color will help you model form and volume.

A mixed technique that uses pastels, chalks, wax crayons, and acrylic paint. A napkin hanging on a line. M. Braunstein.

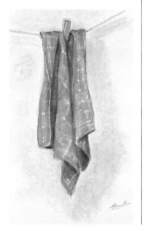

Examples of blending overlapping pigments.

Mixed technique, pastels, and gouache. A dog's head. M. Braunstein.

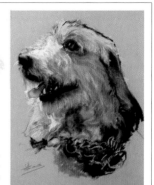

Compatibility

All the dry media tend to be compatible with each other. A commonly used technique involves the use of charcoal and white chalk together. Charcoal worked with sanguine chalk or Conté is another frequently used technique. It is also common practice to work in the technique known as *à la trois crayons*, using charcoal, sanguine, and white chalk on cream colored paper.

Dry media can also be used with oil pastel, with graphite sticks, and with soft drawing pencils. Mixing these media can produce beautiful and dramatic effects. Colored pastel and Conté contain a waxy binder. Their use in mixed dry media techniques is somewhat akin to working with hard pastel, as the color tends to be more muted than intense.

Using Water

You can use water with all the dry media as long as your paper is substantial enough to support it. With charcoal the effect is inky while with sanguine chalks you can get quite a thick layer of paste. Working chalks and pastels with water produces effects similar to a water color painting although less transparent.

Mixed Techniques

Since these dry media can be worked with water, they can also be used with other water based media such as water colors, gouache, acrylics, and inks.

The mixing of these media can be quite innovative, departing from the traditional uses of grading and blending. The results can be beautiful, effective, and original.

Mixed media: acrylic modeling paste, pastels, and acrylic paint. A sports shoe. M. Braunstein.

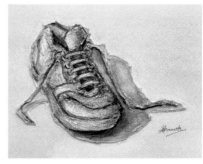

SUPPORTS, CRAYONS, AND PENCILS

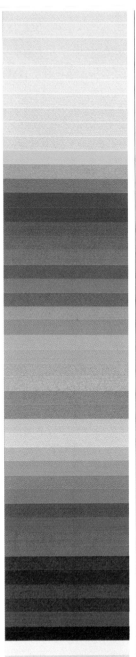

The Mi-Teintes paper by Canson offers a range of 48 colors.

Supports

There are several fundamental qualities to consider when choosing a support to use when drawing with dry media. First, and most important, the support must have the capacity to hold the dry particles of pigment. There are many papers that will hold chalks and pastels, ranging from pastel papers made just for the purpose, to all-purpose papers and even many watercolor papers. Illustration board and cardboard can also be used. Surfaces that have some texture will tend to hold pastel or chalk. Smooth surfaces will not.

The Color of the Support

The color of the support you choose will influence the final result of the work. Whether you work in many layers or leave areas of paper uncovered, its coloration will influence the way pigments look, as well as affecting color interactions between pigments as you work. Your color choices, too, will be influenced by the original color of your paper. A finished piece is always an evolution of the initial marks or underpainting. Canson Mi-Teintes is an excellent paper that comes in 48 colors ranging from neutral to quite intense. Other fine papers include Ingrés Vidalon, also by Canson; subtly textured pastel paper by Rembrandt; and Sanfix paper (which has similar properties to sandpaper) by Schmincke.

MORE ON THIS TOPIC
- Charcoal **p. 22**
- Graphite pencils **p. 24**

The fine surface of Mi-Teintes paper.

An example of the same paper, this time showing the coarse-grained side.

Texture

Paper that has been especially designed for painting with dry media has a different texture on each side. The effects that can be achieved when the color is applied onto them are different.

Other supports, such as sandpaper, brown craft paper, some recycled papers, fabric, and corrugated cardboard produce different effects depending on their texture and pigment-retaining capacity.

There are modeling pastes and other materials on the market that will add texture to the surface of a support.

Crayons and Pencils

The quality of the support, its texture, and color will determine the way your work with dry media develops, as will the various qualities of your media. Conté crayon, chalks, and pastels are available in sticks. Soft pastels are generally cylindrical. Hard pastels are often squared, as is Conté crayon. Hard pastels and Conté are available in pencil form as well.

Although a stick lends itself to the drawing of lines, it is best used for blocking in large areas of color. Chalks in pencil form are wonderful for linear work, though larger areas can

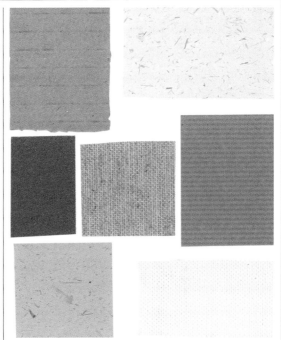

Various textures.

be laid down using fine diagonal lines.

Fingers, Blending Sticks

Fingers are probably the best tools for color blending, as one can have fine-tuned control of color and contrast modulation. Rags and Q-tips can also be used, as can paper blending sticks. Blending sticks come in different sizes and thicknesses, as well as different degrees of density from hard to softer. They are made of rolled, absorbent paper, pointed at the end, much like a pencil. It takes time and experience to develop the facility to work with any of these tools, as well as the eye to discern one's preferences.

Blending sticks.

Fingers.

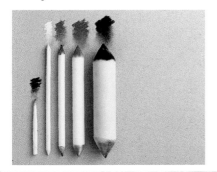

CONTRASTING COLORS AND TEXTURES

Contrasting Colors

We have used Canson Mi-Teintes paper for all the examples illustrated on this page. Although the color of the paper changes, its texture doesn't. In this illustration a variety of pastels have been applied to the coarse-grained side of the paper.

Each color combination of paper and pastel creates its own visual effect. Some colors, such as the orange and blue, contrast strongly and create an active sensation in the eye. Complementary pairs create the greatest contrasts (**F**). Contrast tends to lessen when the color intensity of one or both colors is reduced by adding black, white, or a complementary hue (**D**).

A light color placed on a dark color will appear lighter still. This effect is known as simultaneous contrast, which refers to the phenomenon of relative color perception. The same color will take on a different appearance depending on the color it is placed on, or near (**B**). (Colors have a great capacity for change.)

Warm colors used against a cool-colored support will create exciting contrasts (**E**), and vice versa (**C**). Sanguine chalk on a neutral-colored support creates sharp contrast and a classic look (**G**). If the color of the paper is earthy and dark, working the surface with light colors will create contrast (**A**).

Texture

The variety of textures pictured here are examples of pastel used on paper, cloth, or cardboard. The color sits on top of the surface's texture, revealing its patterns.

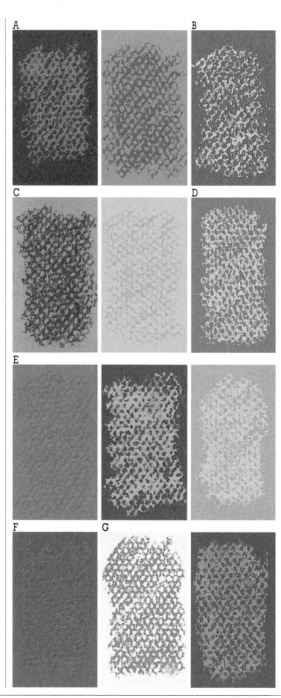

These patterns tend to establish the look of a piece, and can be used to great aesthetic advantage. Exciting color relationships occur as the most superficial part of the relief is colored while its deepest recesses are bare.

Examples of texture using recycled paper (**1**) and (**2**); special paper for dry media (**3**), (**4**); (**5**) and (**8**), coarse-grained paper for watercolors (**7**); sandpaper (**6**) and (**12**); canvas (**9**); wallpaper (**10**); corrugated cardboard (**11**).

1 2 3

4 5 6

7 8 9

10 11 12

Adherence

Pastel paper with a sanded finish allows layers of color to solidly adhere. Pastel will generally adhere well to a coarse grained support. The smoother the surface, the more difficult it will be to apply the color in thick layers.

A paper's capacity to hold the medium is one of the most important considerations when working with pastels. If a piece of paper does not seem to have enough adherence capacity, the problem can be solved by using liquid fixative that can be purchased in aerosol cans. Layers of color are then alternated with light sprayings of the fixative.

Contrast Through Texture

Different textures create a variety of effects that the artist learns to use as another visual element. In the examples shown there are dots, irregular smudges, soft grains, uniform lines, etc., each created by the texture of the support. Textures handled well will give the finished work added vitality. The nature of your subject matter will tend to suggest textures that will heighten certain effects. Landscapes have a dreamy atmospheric look when worked into a sandpaper, or other very rough finished papers.

CHARCOAL

Lines of Different Thicknesses

Charcoal is a medium that is meant to be handled in a loose, free way, allowing for the study of line, form, and contrast. The charcoal stick should be held the way one holds a wall-painting brush, the end of the stick resting against the palm. Charcoal is very fragile, and will break under too much pressure. However, with practice it is an expressive tool, which will readily draw lines of different thickness and character (**1**).

Charcoal is extremely workable, easily and quickly applied. It has a great capacity to create a wide range of tones and can be lightened and erased (**2**).

Creating Shades

Dark and light shading is created by using different degrees of pressure as you work. Light shading is created with gentle pressure. Added pressure will produce darker shades. Four tones are pictured in the left-hand column of this illustration (**3**). In the right-hand column the original tones have been worked and blended, softening their intensity (**4**). Working the charcoal in this way increases its range of expression. Charcoal can be gently or vigorously blended, creating subtle or dramatic changes in tone. To create an even gradation, such as the one pictured here, the pressure of the hand needs to be varied but controlled. Charcoal is the

MORE ON THIS TOPIC

· Graphite pencils **p. 24**
· Charcoal and supports **p. 26**
· Charcoal and sanguine **p. 36**
· Charcoal, sanguine, and white chalk **p. 38**

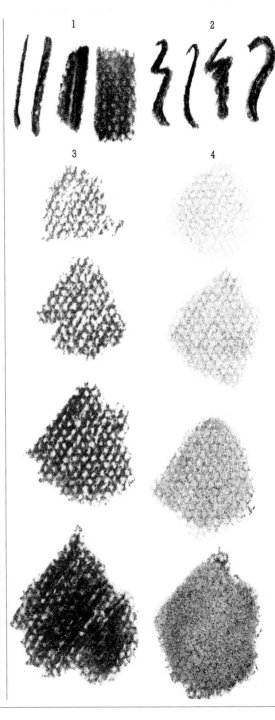

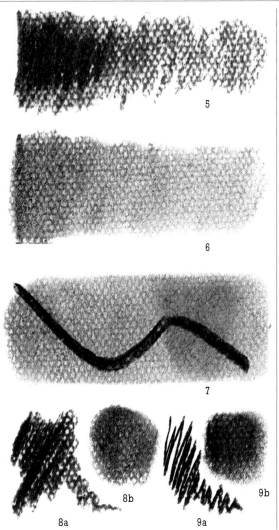

5

6

7

8a

8b

9a

9b

learning to organize a gradual scale so that there are no sudden jumps in tone, just an even, measured progression from the darkest dark to the lightest light (**5**). When this skill has been acquired you have a basic and important tool for the creation of form, and for reproducing the wide ranges of tone the eye sees. A composition needs such a range to be visually engaging. Gaining control over dark to light gradations will help you organize and evaluate your subject matter tonally. The look of charcoal can vary depending on the way it is handled. A charcoal gradation can be done with a soft, gentle look, extending its monochromatic palette (**6**).

Charcoal can be worked to achieve a variety of lines and shadows within the same work. On a layer of blended charcoal, which offers two obvious shades, a line has been drawn (**7**).

Look at the difference in color and intensity of the charcoal in the following examples: charcoal without blending (**8a**) or with blending (**8b**); here an artificial compressed charcoal stick has been used. The black is very intense (**9a**) and shows a blue tendency (**9b**), which has been blended with a finger.

medium of choice for quick tonal evaluations of your subject.

Grading

When learning to produce gradations of value or shades using dry media there are two important goals: one is the achievement of a wide spectrum of tones, the other is

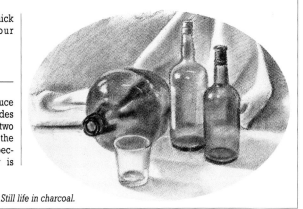

Still life in charcoal.

GRAPHITE PENCILS

Lines, Blocking, Shading

Graphite pencils are used for shading and drawing lines in the same way as natural charcoal or a compressed artificial charcoal stick. However, as graphite pencils are harder, more stable, and, above all, can be sharpened, they allow you to draw many kinds of lines.

When drawing lines, the sharpened point of the pencil allows you to control both thickness and intensity (**1**), obtaining very expressive results (**2**).

In column **3** you can see examples of tonal values obtained by shading and by controlling the pressure of the pencil on the textured surface of the paper. In column **4** you can see the effect of blending on the examples in column **3**.

Column **5** shows how you can use lines to produce tonal values for shading. In the first example at the top (**a**) the shading has been done using diagonal lines. The example directly below (**b**), has been done with a second set of parallel lines, perpendicular to the first (**a**). The shading is intensified with vertical lines (**c**) and finally horizontal lines have been added (**d**).

The linear shading, or crosshatching, is blended (column **6**). Notice that the lines do not completely disappear.

There are countless formulas for creating shade with lines or dots. Any kind of line—straight, curved, circular, thick, thin—or dots of varying sizes can be used to produce shading. Each mark has its own look, and can be effectively used for achieving rhythm, depth, and accuracy.

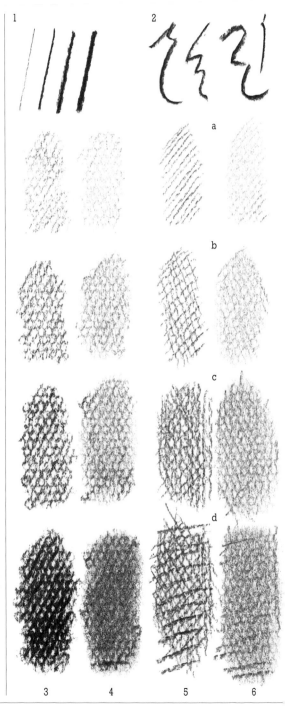

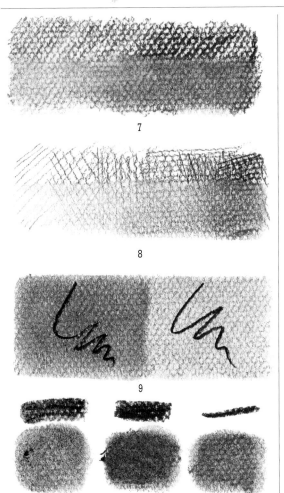

7

8

9

10

Because there is less graphite used, the gradation produced is more delicate than the gradation in (**7**). Exaggerated, and therefore dramatic, shading effects can be achieved by greatly varying the pressure on your graphite.

By alternating techniques of blocking in, line hatching, and blending, you can obtain countless tones and contrasts of texture. Looking at two examples, which have been blended and that have different tonal values, the contrast that these simple lines offer is apparent (**9**).

You can also use the different color possibilities and qualities of the charcoal, the compressed charcoal stick, and the graphite pencil together (**10**). (They appear here in this order from left to right.) Each black has its own shade and color. Their differences become more evident when the blocking in of the three materials is blended.

The blending capacity of each material is different. Charcoal is the most fragile of the three materials.

MORE ON THIS TOPIC

· Charcoal **p. 22**
· Charcoal and supports **p. 26**

Grading and Fading

With a graphite pencil you can create smooth gradations by blocking in, controlling the pressure exerted on the pencil and without leaving any spaces between the lines. In this example of grading (**7**) the lower part had been blended as well, from the lightest part to the darkest.

This gradation (**8**), has been done by blocking in parallel lines. The lower part has been blended with the hand.

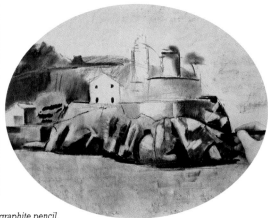

Shading carried out using a graphite pencil.

CHARCOAL AND SUPPORTS

The Color of the Support

In the examples given on pages 24 and 25 you can see tones on white paper. Tones and values can, of course, be created on any color support.

When choosing the color for the support or the paper that you are going to draw on with the charcoal, it is helpful to bear in mind the effects of simultaneous contrast. Dark colors will tend to make lighter tones (or colors) read lighter than they would on white. So a dark gray paper, for instance, will require greater attention to the range of contrasts you create with your charcoal than will white paper. Darks will need to be strong, and the gradation of dark, medium, and lighter tones will need to be well organized and carefully considered for them to have as much effect.

The Canson Mi-Teintes 420 Maize (**1**) and 453 Orange (**2**) paper has been shaded on the coarse-grained side. While the colors differ, the texture is the same.

The examples show, in three tonal values, shading done with charcoal (with an oval area blended by thumb) and a line drawn with a graphite pencil (with an area that has been blended, in this case, with the index finger).

The tonal values have been created with the uneven pressure applied to the charcoal and the pencil. They are graded from a lighter shade, above, to a darker one, below.

The effect that each different color of paper produces has a different psychological weight. Even a beginner working with charcoal, a simple and fundamental tool for an introduction to drawing, can achieve great results if the background has been well-chosen.

1 2

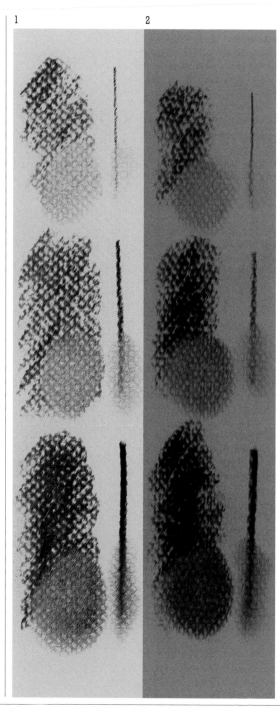

The Texture of the Support

The different texture of a support can play an important role in the effect charcoal produces. Here, the white hand-made paper (**3**) has a nubby finish, while the blue (**4**) has a vertical stripe that shows up with shading. The color differences also influence the final result.

Charcoal has been used for the thick line and graphite pencil has been used for the fine line, just as in the previous exercise. A portion has been blended by rubbing with the thumb.

The unevenness of the grain of the support (**3**) creates an airy effect while the vertical position of the texture of the support (**4**) gives the charcoal an ordered look.

The sensations produced by the effects of simultaneous contrast (caused by the color of the papers) on two different charcoal-worked textures are also distinct. A colored support can produce work of surprising beauty.

Note that on a cool background such as this blue, a particularly moody, dramatic effect is created by the contrasts. With the exception of black and very dark neutral colors, any color can be used as a base for black, dry media.

Choosing the Right Texture

Particular support textures and colors can highlight or soften the effects that blending produces. Notice the different look each paper produces.

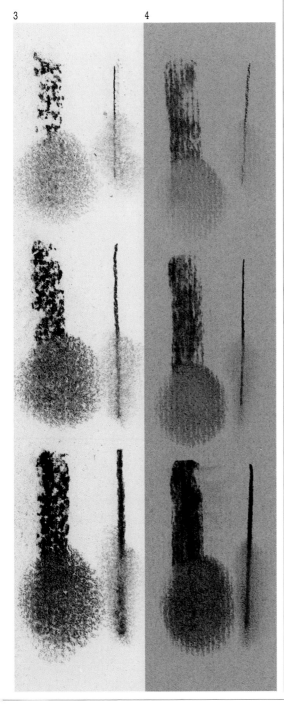

3

4

MORE ON THIS TOPIC

· Charcoal **p. 22**
· Graphite pencils **p. 24**

SANGUINE CRAYONS

Lines

The hardness of the sanguine Conté crayon, harder than that of charcoal, allows you to draw a wider variety of lines of different thicknesses (**1**). Sanguine can also be sharpened with a cutting tool for more refined lines (**2**).

Blocking In

You can also use sanguine to create tones, just as you can with charcoal. Look at the scale of tones in examples (**3**) and (**4**). The lighter tonal value has been achieved by pressing lightly on the crayon. The pressure should be increased to get more intense tonal values.

The character of sanguine's strong covering ability can be seen in column **4**. Some blending has also been used here. Compared to charcoal, sanguine is more difficult to blend because of its density and wax binders. As the shade gets darker with blending, the depressions in the paper are completely covered. When blending a dark tone of sanguine Conté, this maximum intensity has the effect of saturating of the paper with chalk. If you try to overlay color onto a saturated area, you will find that the work will not accept any more pigment. A deep shade such as this will lack nuance and subtlety. Instead, it is recommended that shading be done in a light-handed way when working with sanguine Conté. It is the gradual superimposition of light layers, successive fading and blending, which will give

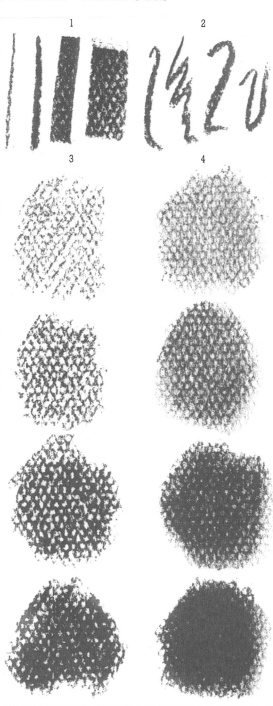

1

2

3

4

MORE ON THIS TOPIC
- Sanguine pencils **p. 30**
- Sanguine and supports **p. 32**
- Charcoal and sanguine **p. 36**

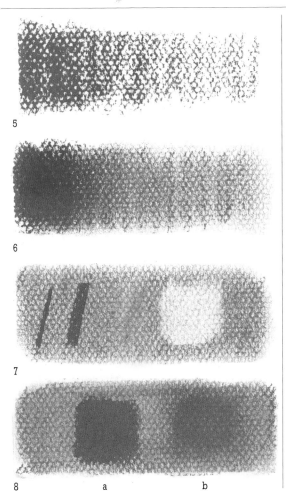

5

6

7

8 a b

great adhering capacity, and it takes some practice to master the manipulation of its tones.

Sanguine is very workable and offers a wide range of effects. In example (**7**), on a uniformly colored and faded background, two lines of different thicknesses have been drawn. In addition, rubbing out (with a soft eraser) has recovered a light area of the uniform background. Because of Conté's binders the eraser does not rub out all the sanguine, but it does allow you to correct mistakes and open up some light areas.

Example (**8**) demonstrates how to obtain different tones by superimposing alternate layers, blending lighter, then adding darker tones.

Here the square has been blocked in first, then a light color has been applied and the example finished off by blending and merging the edges.

Alternating these techniques for achieving tones, sanguine allows for a wonderful richness of shades, and can be used to draw any subject with great effect, particularly portraits and figures. Sanguine is a dry medium that possesses a variety of warm colors ranging from russet red to sepia.

you deeper shades that have rich tone changes.

Fading

In example (**5**), a gradation of tones has been blocked in from a dark to light while avoiding jumping from one shade to another.

To blend this gradation, work from the lightest tone to the darkest (**6**). If you did this the other way around, you would carry the pigment from the dark area and lose light, subtle tones. Sanguine has

Still life done with a sanguine pencil.

SANGUINE PENCILS

Lines

With sanguine pencils you can draw lines of different thicknesses and intensity (**1**). Sanguine is harder than charcoal and its range of possibilities for creating expressive lines will make for rich tonal interactions (**2**).

Blocking In and Crosshatching

A work of art can be colored in by using successive lines that cover its surface; different tonal values can be created by varying the pressure on the pencil as you draw (**3**). In the same way, different tones can be blended (**4**) trying to maintain a harmony of tone.

With the sanguine pencil you can also shade using lines or crosshatching (**5**). The lighter shades can be obtained with parallel lines in the same diagonal direction (**a**). In (**b**), crosshatching is created with strokes that are perpendicular to the first ones. If you add another overlay of crosshatching with horizontal lines, you can obtain a darker shade (**c**). Finally, shading is completed with vertical lines (**d**). Shading with lines and crosshatching will enable you to model form and create shadows with rich variations and nuance.

In the examples shown in example (**6**), different shades have been blended progressing from the lightest (top) to the darkest (bottom). If you learn to maintain this kind of order of tones, you will have an effective tool for creating convincing volume. The binders in sanguine Conté ensure that the look of

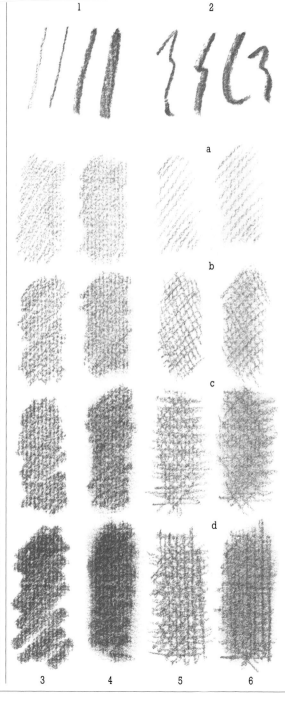

MORE ON THIS TOPIC

- Sanguine crayons **p. 28**
- Sanguine and supports **p. 32**

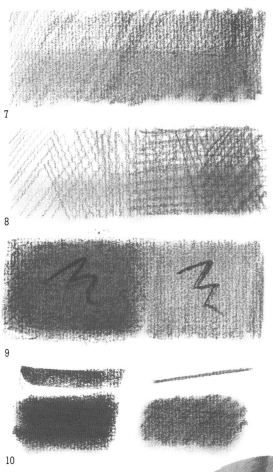

7

8

9

10

A grading obtained by shading with hatched lines (**8**) creates another look. Again, do your blending by moving your finger from the lightest area toward the darkest. As before, the lines can still be clearly distinguished.

Alternating Techniques with Crayons and Pencils

With two examples in two different tones, blocked in with sanguine Conté crayon, blended, edges merging, the lines drawn with the Conté pencil contrast effectively (**9**). The technique of blocking in has been alternated with that of line-shading. The darkest shade has been darkened next to the lightest one and the lightest tone has been lightened next to the darkest one.

Alternating sanguine crayons and pencils in the same piece of work allows you to work in hues of subtle variation and add texture as well (**10**). The color of the line drawn with a crayon is darker. It retains its darker color when blended. The color of the pencil is redder whether you are using it to make blended areas or simple lines.

crosshatching will remain even though you work and blend the chalk. Highlights can be added with white chalk, pastel, or Conté crayon.

Grading

Varying the pressure as you shade with the sanguine pencil will allow you to create gradations. Pressing down harder will create darker patches (**7**). To soften the gradation use your index finger to gently blend from the lightest tone toward the darkest.

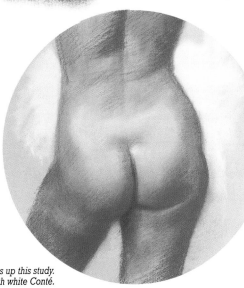

A complex series of tones makes up this study.
It has been highlighted with white Conté.

SANGUINE AND SUPPORTS

The Color of the Support

If you want a support that will work in harmony with the warm characteristic of sanguine, you can choose a warm neutral color (**1**). A cool color as a support, (**2**) in this case blue, produces high contrast and a quite different overall effect. Without doubt both methods are attractive. The possibilities of expression that are opened up by including the background color in the work (maintaining areas of the support completely free of the sanguine) make for exciting color interactions as well as all kinds of dramatic effects.

Many colors can be used as a base when working with sanguine, as long as there is enough contrast so that the chalk reads visually. In the examples shown we have created different shades by varying pressure on the crayon and pencil. The top tone is pale, made with a light pressure. The darker tone is obtained by using more pressure.

In addition, part of each line has been blended using a gentle circular movement of the thumb. Blending must be done with care to maintain a graded series of shades.

Charcoal and Sanguine. Their Adherence to the Support

Charcoal and sanguine differ from each other in the way they adhere to the support. While charcoal is delicate to work with and easy to lift off by blending with a rag or erasing, Conté sanguine is a substantial and stable medium. Compare with the results of charcoal on page 22. See the possibilities that their joint use offers on pages 36 and 38.

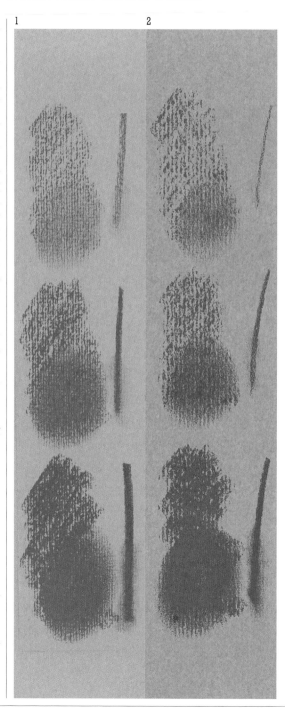

1 2

The Texture of the Support

Choosing a specific texture for the support is especially important in relation to the final result of the work. On the previous page, the paper had a texture with vertical bands that become more visible with the drawing medium. The effect was uniform and regular.

The examples given next deal with two irregular textures. One of these is coarse-grained (3) and the other is of a much finer grain (4). These are newsprint papers that are frequently used for sketches and rough outlines. Their warm off-white color offers a good contrast for the sanguine.

On each piece of paper, lines from lesser to greater intensity have been drawn from top to bottom. The effect of the blending is different on each type of paper, finer on paper of type (4), which is smoother.

The effect of the high contrast is different on each support since each is of a different color. Some subject matter will be best represented on smooth textured paper, while others may require a rougher texture. Smooth textures allow for finer detail, while rough textures have the potential to create an impressionistic look.

Since the texture of the support plays such an important role it is wise to experiment with various papers. The great adherence capacity of sanguine makes it a medium that can be used on supports with a great deal of texture. Textures can also be prepared by applying acrylic modeling paste, rubber solutions, and other texturizing substances, which can be purchased at an art supply store.

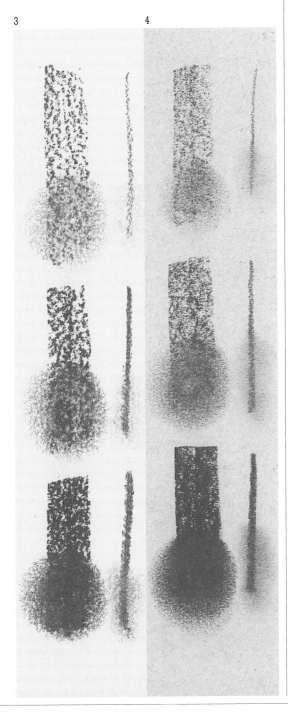

3

4

MORE ON THIS TOPIC

- Sanguine crayons **p. 28**
- Sanguine pencils **p. 30**
- Charcoal and sanguine **p. 36**
- Charcoal, sanguine, and white chalk **p. 38**

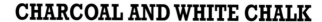

CHARCOAL AND WHITE CHALK

Charcoal and White Chalk

Using charcoal and white chalk together is common practice. It is a useful mixed technique for drawing sketches and for easily indicating areas that are much lighter; its possibilities for developing the effects of chiaroscuro are many.

The following are some ways to work with charcoal and white chalk, on a common background color.

1. The background color should give a contrast to the charcoal as well as to the chalk whenever the medium is in direct contact with it and without any mixing. A sheet of white paper, for example, does not allow you to distinguish the white chalk lines with clarity. Here you are given two examples of textures and two neutral colors, one of which is lighter than the other (**1** and **2**). The charcoal and the chalk have been applied to create shades. Blending illustrates the effect on each shaded area.

2. The effect of blending is different for each medium, the charcoal being much more volatile than the chalk.

3. On a gray background, the tonal values have been ordered (from the darkest to the lightest) with a mixed technique using charcoal and white chalk and blending (**3**). To organize these tones, the most intense tone of the charcoal is obtained by using heavier pressure. The pressure is gradually lessened to obtain the lighter tones. The gray color of the paper functions as the intermediate shade. Using the white chalk, first press down lightly to obtain the lightest area of white, then use more and more pressure for each subsequent area of white until it is most intense, or the highest white.

1 **2**

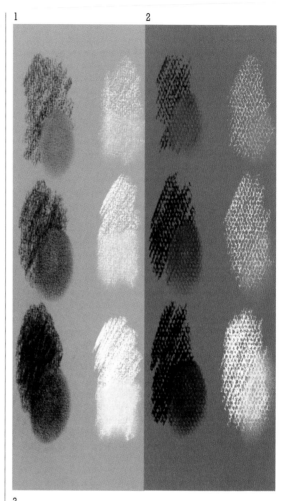

3

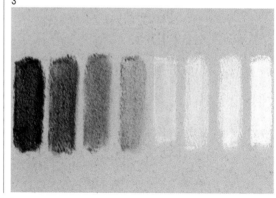

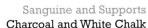

MORE ON THIS TOPIC
- Charcoal **p. 22**
- Graphite pencils **p. 24**
- Charcoal and supports **p. 26**

The grading has been blended to create the quality of the chiaroscuro. To make sure that this blending process is smooth, pass gently and carefully from one value to another, creating an orderly progression without skipping any tones. First blend using vertical motions, then blend horizontally. Try to keep the lighter areas bright.

On a grading between charcoal and blended white chalk (**5**), charcoal lines will stand out dramatically. However, the line made with white chalk offers contrast only against the black or gray areas. When you blend from the white chalk toward the charcoal, the result of the grading, in general, will be lighter (**6**). Working from the darker area toward the lighter end will produce a dark result (**7**). Keep this in mind when reproducing the lights and shades of your subject using chiaroscuro. The direction of the blending should function to build form and construct space. Again, bear in mind that the color of your support will set the tone and affect the look of the finished drawing.

Grading

These examples of using charcoal and white chalk opaquely are done on Mi-Teintes 429 Smoky Gray (**4**). On the left-hand side the charcoal has been applied with heavy pressure then lightened progressively. On the right side the white chalk has been applied using heavy pressure. The pressure on the white chalk lessens progressively from right to left as it merges in the center with the charcoal to make gray.

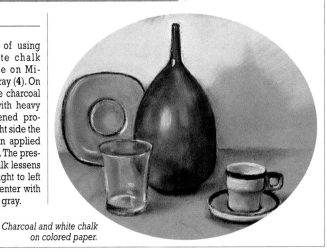

Charcoal and white chalk on colored paper.

CHARCOAL AND SANGUINE

The Method

Working with charcoal and sanguine together on white paper enables you to achieve a wide range of tones and colors. Here are some examples:

Charcoal enables you to obtain different shades by varying the pressure you use as you draw. Then each tone can be blended to create additional tones and nuances (**1**).

The charcoal pencil creates shading by using parallel lines, or hatching. Blending creates nuances (**2**).

When charcoal and sanguine are mixed you can create deep, rich browns, using them to make gradations that can create form. The samples (**3**) have been blended and put in order from darkest, left, to lightest, right.

Exerting more or less pressure on the sanguine as it is moved over the paper creates different tones. Blending or softening will create more variation (**4**).

When using charcoal and sanguine together the differences between the two media become more obvious. To see this you only have to touch them: rub together the tip of your forefinger and thumb, having covered them with charcoal. Then clean off the charcoal and do the same with sanguine. The charcoal blackens the skin, but it disappears as you rub your fingers together. The sanguine, however, leaves a thick, greasy film, because of its waxy binder.

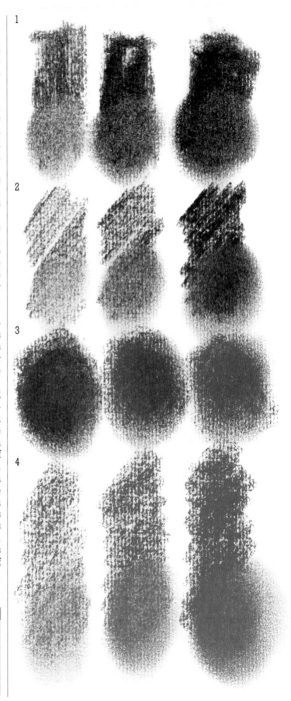

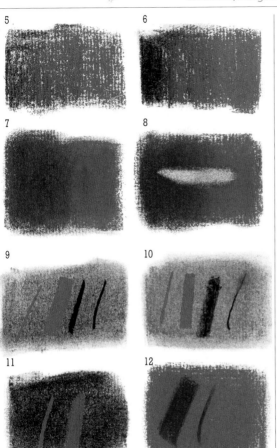

You can open up white areas in softened opaque blending areas by rubbing with a soft eraser (**8**). The general quality of the paper's color is recovered, although it does not entirely return to its original white, which enables you to correct mistakes, and leaves a tone that can enrich the work. Creating a variety of tones and colors gives weight and richness to the finished work.

The next two examples (**9** and **10**) offer interesting contrasts of tone and color. The strokes of each medium are clearly visible on backgrounds of faint, blended colors, but as you can see, the effect is very different in each case.

On opaque, blended backgrounds of charcoal and sanguine, lines of the other medium are drawn respectively (**11** and **12**). Note the thick and fine strokes.

The options on these two pages are only some of the ways charcoal and sanguine can be used together, alternating coloring and line techniques.

Bear in mind the different characteristics of charcoal and sanguine as you use line and blending. Practice will teach you how to work with them, experimentation will teach you how to use them to build volumes of form.

Blending with Charcoal and Sanguine

You can create blended areas by laying down the sanguine over a layer of charcoal. The general effect is quite transparent. In example (**5**), the blending is more transparent than in example (**6**). The first example leaves the color of the paper visible, while in the second the chalk is more opaque, almost completely covering the white of the background.

Note the result of softening opaque blending (**7**).

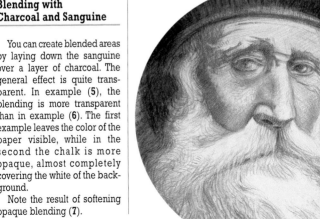

Portrait (sanguine and charcoal).

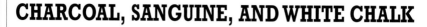

CHARCOAL, SANGUINE, AND WHITE CHALK

Another Method

Another method for doing tone studies combines charcoal, sanguine, and white chalk, further extending the possibilities of chiaroscuro. Here are some ways to work with those materials, using a darker, tan colored paper.

Many different shades and colors can be created using charcoal, sanguine, and white chalk by working these in different ways. Here the three media can be seen blended and softened (**1**, **2**, and **3**).

The order in which one color is applied over another effects the result. The following areas of tone have been done applying about the same amount of pressure for each shading.

Example of sanguine over charcoal (**4**).

Here, charcoal has been shaded over sanguine (**5**).

Sanguine applied on top of white chalk brings up the red hue (**6**).

White chalk over charcoal (**7**) emphasizes the white strokes.

A similar effect occurs when working white over sanguine (**8**).

In example (**9**) charcoal has been applied over white chalk. Notice how the charcoal dominates.

Great variation of tone, color, transparency, and opacity can be achieved using these three mediums together.

The circular blending in examples (**4** to **9**) shows the

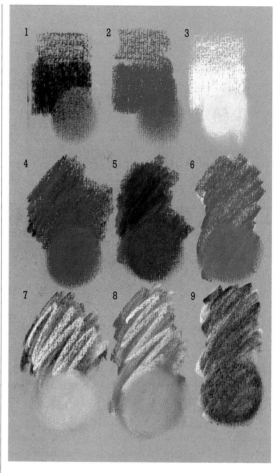

result of their mixing. Placing these colors into an ordered gradation, working from dark to light, will give you a wide tonal range.

An example of ordered values (**10**), on Mi-Teintes 453 Orange paper.

10

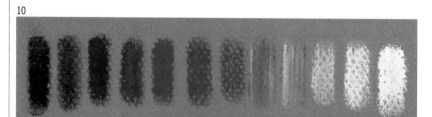

and lightened toward the right side, sanguine has been applied using the edge of the Conté stick (**13**). Observe the effect.

The layer of charcoal in this case is uniform and the sanguine is again applied on top (**14**). Using the paper's irregular texture, the color effects are quite beautiful.

Next, a layer of charcoal is applied over a faint sanguine coloring (**15**). To do this, use the side of your charcoal stick. The result is darker and richer in tone than in example (**14**).

Charcoal and sanguine can also be blended and softened to produce opaque effects (**16**) that will cover the grain of the paper.

Creating an opaque area, then blending to soften, creates a smooth transition between sanguine and white chalk (**17**); charcoal and white chalk (**18**).

As you can see, the white chalk has a subtle, brightening effect against the neutral color of the support.

Remember that the white of the chalk will not show up directly on the support unless the color of the support allows it.

MORE ON THIS TOPIC

· Charcoal **p. 22**
· Sanguine crayons **p. 28**
· Charcoal and white chalk **p. 34**
· Charcoal and sanguine **p. 36**

The Importance of the Support

A background of off-white, with an irregular texture, shows off the chromatic qualities of the three media: charcoal, sanguine, and white chalk. The contrasts can be seen between the charcoal, white chalk, and blending (**11**). Similar contrasts are shown here using sanguine and white chalk (**12**).

Over a faint charcoal coloring that has been quite blended

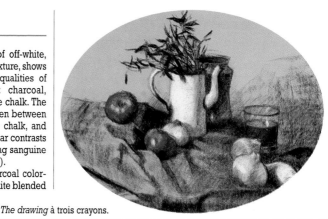

The drawing à trois crayons.

CHALKS AND PASTELS

Chalks and Pastel Colors

These two pages show samples of 56 colors. You will find that the color white and tinted whites can be better appreciated on some of the following pages when the color of the support provides some contrast.

All reputable brands of pastel offer a wide variety of shades and tones of color. In general, however, not as many colors are found in the ranges of hard pastels as in the ranges of soft pastels. Many artists use chalks rather than pastels to begin the subject. As chalk is a workable medium, it is easy to correct errors. And, owing to its hardness, a heavy line can be drawn without the stick of chalk breaking, when soft pastel would not only break, but crumble. Mixtures of pastels tend to reduce the paper's adherence capacity, producing a muddy appearance and losing the color. The wide ranges of colors for hard and soft pastels lessen the need to mix. At the same time using fixative extends the holding capacity of paper and pastel. Using it properly you can paint by blending, grading, and superimposing layers that introduce subtle color and tone distinctions.

How to Work with Pastels

Generally, one works with many colors of pastels in one composition, toning the color by means of blending, grading, and superimposing layers both when blocking in and when drawing lines.

Chalks and pastels carry a considerable load of pigment. The soft pastels have the purest colors, as can be seen in these samples.

The character of pastel is dusty. This makes them fragile

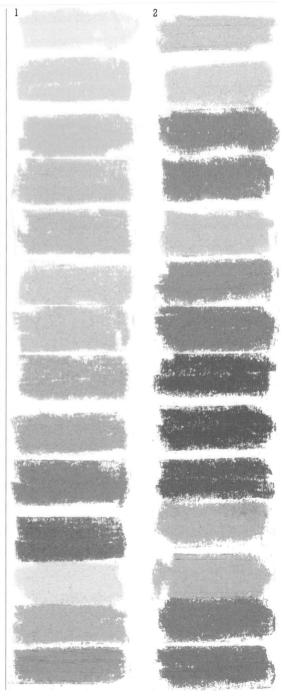

1

2

and difficult to conserve. Columns (**1**) and (**2**) show a selection of warm colors. Column (**3**) shows cool colors. The colors in column (**4**) are neutral colors. Works done in neutral colors tend to have harmony and great beauty. Work done with neutral color and intense color takes some practice, but has great potential for harmony and beauty as well. The color juxtapositions offered on these two pages enhance their chromatic qualities. The contrast between warm and cool colors suggests their exciting potential for the finished composition. As you work the color they will lose their purity. Fixative, sprayed in alternate layers with worked pastel, will enable you to recover color brightness and intensity. Working the pastels from underpainting to full development will require practice and experimentation.

Special Ranges

There are special ranges of pastel colors, sold commercially for specific subjects. Those for portraits, seascapes, and landscapes are very common. A box that contains a special range for portraits will contain all the colors necessary to represent all possible skin tones.

Ranges of white, black, and gray pastels are also sold. These may include warm grays and cool grays. White and black pigments are blended to make these pastels. Blue, violet, red, or green pigments are present in minute quantities in order to make them warm or cool. The color samples in (**a**) show a warm gray, a cool gray, and black.

3

4

a

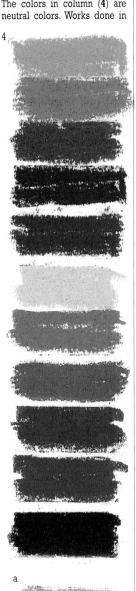

MORE ON THIS TOPIC

· Soft pastel colors **p. 14**

MIXTURES WITH CHALKS AND PASTELS

Limitations of the Mixtures

According to the color theory presented here, secondary green is obtained by mixing primary yellow and blue in equal parts. The secondary blue or purple blue, can be obtained by mixing, in equal parts, primary crimson and blue. Lastly, the secondary red is the result of mixing primary crimson and yellow in equal parts.

In practice, this yellow and blue mixed together gives an earthy greenish color, which we have blended here. You can see that the green, such as the one shown in the pure pastel example, is much more color saturated. Mixing colors will also saturate the surface of the paper with the pastel material itself (**1a**). We've repeated this mixing exercise with reds, (**2a**) and (**2b**). The pure red pastel is more intense in color. The same can be said of the secondary blue in the examples given in (**3a**) and (**3b**).

The problems of saturation of the paper can be lessened by applying fine uniform coats of a liquid fixative.

Pastels and Mixtures

If you mix and grade yellows and blues you can obtain greenish yellows, greenish blues, and greens. The range depends on the particular yellows and blues you use. Grading yellow and crimson, for example, will give you a range of oranges and reds made up of the chromatic characteristics of the original yellow and crimson. A crimson and a blue will allow you to work with colors ranging from dark blue, violet-blue, violet, to crimson-violet. Again, the range will depend on the chromatic char-

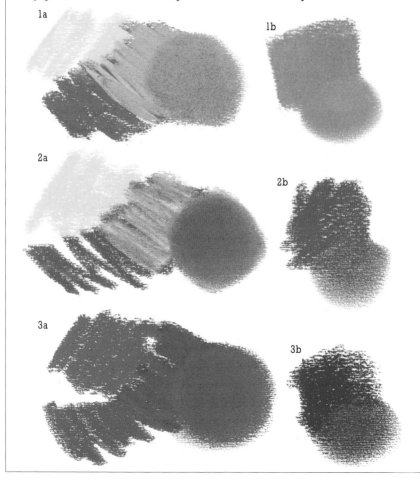

1a

1b

2a

2b

3a

3b

acteristics of the crimson and blue that you begin with. When working with pastels the artist is dealing with both hue (coloration), and tone (darks and lights). Blending bright (saturated) colors with colors that are darker or grayer will create the effect of chiaroscuro.

Another crucial point is the incorporation of white in the light tones. Whites and other pale hues will lighten color and create tints.

Testing the Limitations of Mixtures

In the next example we will mix 3 neutral colors: ochre, sienna, and dark gray/brown.

Ochre can be produced by mixing a lot of yellow, a little crimson, and a touch of blue. Sienna is formed by mixing crimson and yellow in equal parts, blending with a little blue. Brown contains crimson and blue in equal parts, to which a little yellow is added. In examples (**4a**), (**5a**), and (**6a**) the mixtures are optical; those in (**4b**), (**5b**), and (**6b**) have been obtained by blending. In (**4c**), (**5c**), and (**6c**) we have used pastel colors from sticks that are the most similar to the mixed colors.

Like the examples on the previous pages, blending of color will add nuance, opacity, and, used with some acquired skill, will help you model form

and depict space.

1. The color obtained by blending is muddier than the pure manufactured color.

2. Blending tends to saturate the surface of the paper, taxing capacity to hold the pastel. Fixative, sprayed in light layers, will enable the surface to be worked further.

3. Working with bright hues and deeper, more earthy tones will enable you to create light and dark tones as you work with color.

MORE ON THIS TOPIC

- Transparent mixing of two colors **p. 44**
- Opaque color **p. 46**
- Grading **p. 50**

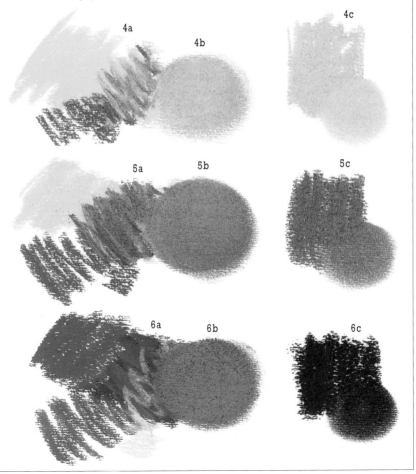

4a
4b
4c
5a
5b
5c
6a
6b
6c

TRANSPARENT MIXING OF TWO COLORS

Application

In these examples the colors have been applied thinly, using both lines and broad patches.

The pink color of (**1**) leaves, by blending, a semi-opaque layer that allows you to see part of the whiteness of the support (**2**).

This crimson pink color (**3**), produced by blending (**4**), creates a pastel wash that also allows you to make out the white of the support. The contrast between the two colors and the paper is modified by blending.

One color can always be used to modify another. When this is the intention, one color must be thinly applied over the color to be changed. Compare the colors in the left column. They are optical mixtures. They become actual mixtures in the right-hand column through blending. The mixtures obtained by blending are less intense than the optical mixtures.

A clear violet allows you to modify and darken a light pink (**5**). Blending the area (**6**) will produce a darker layer of color than the initial pink.

A blue allows you to darken and modify a bright green (**7**). In example (**8**), the color is blended, creating an earthy green.

Using a pale gray you can lessen the intensity of an orange color (**9**). By blending (**10**), the brightness of the orange has been reduced.

Bear in mind that control over the intensity of the color-toned or line drawing is

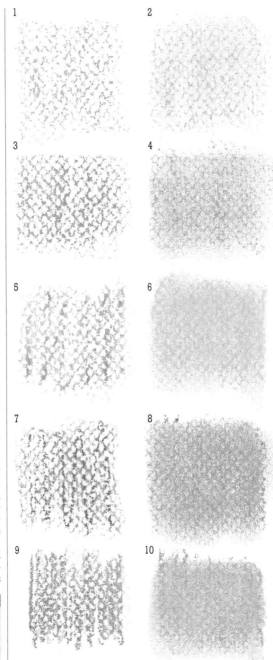

1 2

3 4

5 6

7 8

9 10

MORE ON THIS TOPIC

- Mixtures with chalks and pastels **p. 42**
- Opaque color **p. 46**
- Grading **p. 50**

dependent on the pressure that is applied to the pastel as you draw. Greater pressure on the stick will produce a more intensely colored area or line.

The color of the paper will tend to show through repeated applications of color if the layers are kept thin. Here you can see the result on a white background.

Next, you will see the same effect but with another background color.

Thin Layers on a Color Background

The thin layers of pastels on a colored piece of paper establish optical effects created by its texture. The optical effects of the mixture are modified with blending.

Pink applied in a thin layer (**11**) has a strong vibrant effect that disappears with blending (**12**). The blue of the paper modifies the effect of the pink.

This crimson pink creates an optical effect with the blue of the paper when applied smoothly (**13**). The blending makes the contrast between both colors disappear (**14**); the blue of the paper furnishes a colder shade.

The mixture of oranges gives rise to an intermediate color created by optical effects (**15**). The medium orange color is created by blending, (**16**), darkened by the blue of the paper.

Greenish yellow modifies orange-yellow (**17**). After blending, the color of the paper makes the layer of color clearly greenish (**18**).

The darker green serves to modify a lighter green (**19**). The blending process and the color of the paper make the layer seem darker than it does when optically mixed in (**20**).

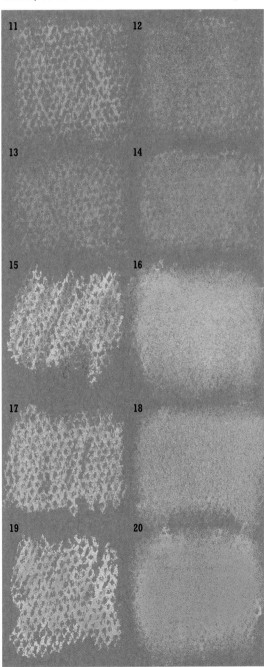

The Color of the Support Affects the Optical Effects of the Mixtures

When the support is not white but colored, dramatic interactions will be created between the paper and pastel colors.

When the support offers a great contrast with the pastel colors, the intensity of simultaneous contrasts (visual changing of color) is at a maximum. This lessens when the support is of a similar color.

OPAQUE COLOR

Opaque Coloring

The color applied to the paper, in this case white paper, when pressing down hard on the pastel stick produces a layer of opaque pigment that covers the paper (**1**). Blending it with your finger will create complete coverage of the surface of the paper (**2**). Thick coloration such as this saturates the paper. This type of thick application is sometimes used during the first stages of working a pastel picture.

If you highlight the yellow with some lines in orange (**3**), the mixture will be optical. Any kind of line will do. In (**4**), the blending produces a medium orange color.

Practicing with different kinds of pressure on the orange line (as in **3**) will give you an idea of the effects you can create to obtain a darker optical mixture. Blending the patch will produce an even, opaque, and darker orange color. When modifying pastel colors by working over them in this way you will achieve different results depending on the thickness of the undercoat or the superimposed lines.

Opaque Colors Side by Side

Opaque colors worked side by side create various effects. Look at these examples: a red and a crimson-violet (**5**), a light violet and a dark neutral color (**7**), two blues (one light and the other darker) (**9**). With the blending process the boundary between colors can be merged, moving smoothly and progressively from one color to another (**6**, **8**, and **10**), and reducing the contrast between the colors.

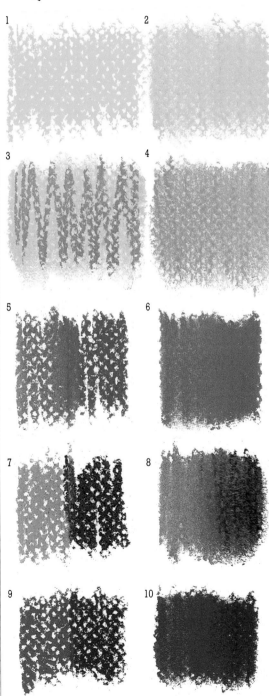

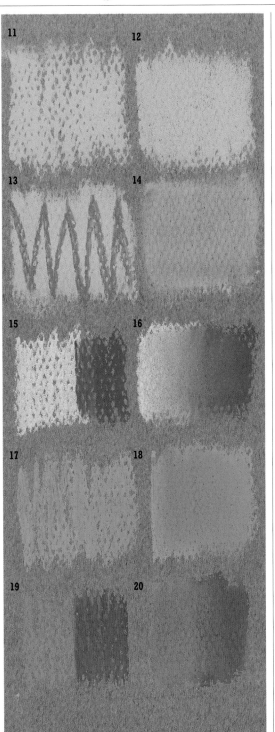

The Color of the Support

These examples, done on Mi-Teintes 429 Smoky Gray paper, confirm once again the importance of choosing a strong color for the background.

Look at these suggestions:

The pink color interacts with the gray paper (**11**). Here it is blended (**12**). This blended pink has been intensified by using darker crimson red lines (**13**). By blending (**13**) you obtain a darker mixture (**14**) than (**12**).

Here are two different tones of blue (**15**), two greens (**17**), and finally two oranges (**19**). Look at the result of blending the pairs of side-by-side colors. The beauty of the blended colors of (**16**, **18**, and **20**) against the gray paper is dramatic. We have offered examples that create an interesting color contrast with the neutral color of the paper.

The Magic of Chiaroscuro

Knowing how to apply colors from light to dark, transparent to opaque, and how to blend them when they are side by side is basic to the technique of pastel. Learning to control darks and lights will create the effect of light and shadow, the magic of chiaroscuro as you depict your subject matter.

MORE ON THIS TOPIC

· Mixtures with chalks and pastels **p. 42**
· Transparent mixing of two colors **p. 44**
· Grading **p. 50**

TRANSPARENT GRADING

Controlling the Pressure

A transparent gradation of a color is an organized range of tones of that color that allows the color of the paper to show through the pastel.

In this example, a lightly applied gradation of pink is blocked in (**1**). You can see the lines that make up the patch of color drawn diagonally on the texture of the paper.

The smudging of color (**2**) blends the lines, making them nearly disappear. The grading appears very smooth, its intensity increasing where the pressure of application was greatest. To achieve a smooth transparent grading, it is important to learn to control the pressure with which you use the pastel. Pressure should be increased little by little or lessened gradually, depending on the effect you are trying to achieve.

Linear shading can be done with the point of a pastel pencil or with the edge of one of the sides of a pastel stick. Here the line has been left clearly visible and even exaggerated in order to demonstrate the optical mixing that is produced by the white of the paper and the pink of the pastel. Notice that this is also a gradation (**3**).

The effect of blending such a linear gradation (**4**) is very different from that of example (**2**).

Several Expressive Effects

Starting from blocking in patches of color or lines, you can obtain very different effects. Choosing one will depend on the look you want, the texture of the paper, and your subject matter, but all these techniques aim to produce a representation (on a two-dimensional surface) that expresses volume and depth.

1

2

3

4

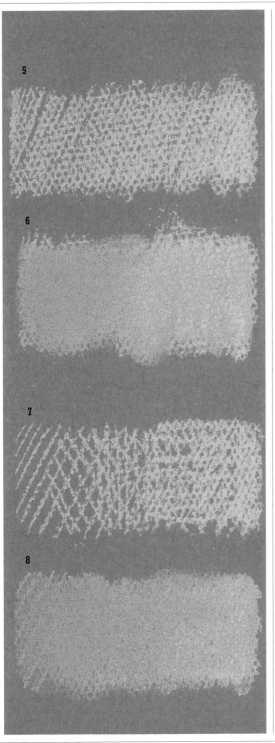

On a Colored Background

A transparent grading on a background color other than white, for example this blue, Mi-Teintes 595 Turquoise Blue, allows you to achieve a strong color interaction.

Yellow is applied first, with light diagonal lines. The pressure should be increased gradually to obtain an intense shade. Here is a transparent grading of yellow on a blue background (**5**). The blue acts more strongly upon the lighter layer of yellow.

Blending the gradation (**6**), produces a greenish color where the yellow area is lightest.

Again, a gradation can also be blocked in using lines (**7**). The most intense tones are obtained by adding more pressure to the line, with lines drawn in several directions. Here, blending the gradation allows you to soften the lines (**8**).

The Artist Uses Many Effects

A pastel artist typically combines different pastel techniques. Transparent and opaque gradations are alternated.

The color of your paper, as we have seen, plays an important role in the overall color interaction, creating visual mixtures of pastel and paper. These optical mixtures are strongest when the color is applied in fine layers.

MORE ON THIS TOPIC

· Mixtures with chalks and pastels **p. 42**
· Transparent mixing of two colors **p. 44**
· Opaque color **p. 46**
· Grading **p. 50**

GRADING

Opaque with Several Colors

For this grading (**1**), six different colors of green have been used. They range from pale green, passing to bright and yellowish green, to apple green, a darker green, and two bluish greens, the last quite intensely blue. Each picture generally calls for one or several ranges of color with which to work. We will use the following examples to practice color grading. It is a good idea to choose your colors and line them up in order.

Using the grading shown in (**1**), blend the colors using your index finger (**2**). Blend using a vertical motion, paying particular attention to the border where the colors meet. This blending of colors should be done in order, moving from pale green to blue-green. Keep your colors pure, only blending those that are adjacent. Blending in the direction of light to dark will keep the gradation light. A darker gradation can be achieved by blending from the darkest color to the lightest.

Transparent with Several Colors

This gradation of greens is an example of achieving an organized range of color by means of fine layers. Color gradations can also be blocked in using diagonal lines. Without blending, optical mixing will occur (**3**). Lines are applied with the pastel pencil or the fine edge of a pastel stick.

Blending example (**4**) has a different effect than the one in example (**2**). The color intensity is less as the layer of pastel does not completely cover the white of the paper.

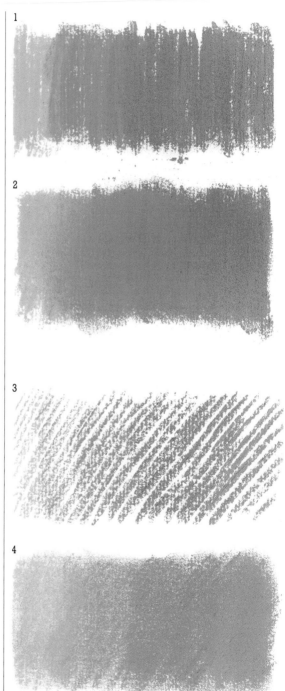

1

2

3

4

On a Colored Background

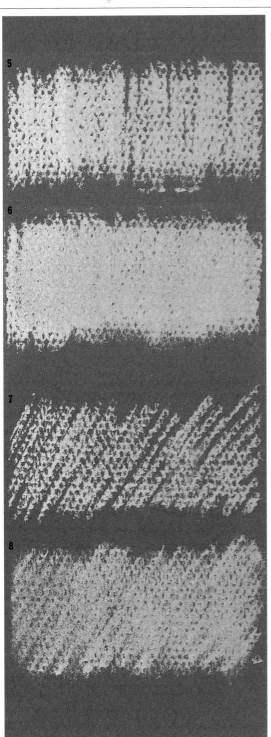

On tan Mi-Teintes paper, a set of five colors from the yellow-orange range is used to create an organized color gradation (**5**).

Using blending, this progression is made opaque (**6**). Another layer of color can be applied to create complete opacity. Again, take care to blend each color only with its neighbor. A delicate touch and attention to cleanliness (especially of the fingers doing the blending) are critical at this point. If you keep the colors progressing evenly and in order, you will gain a powerful tool for creating form using color gradations.

In example (**7**) the grading is accomplished with diagonal lines. Again, allowing the paper to show through creates optical mixtures (**7**). The diagonal direction of the lines conveys motion and rhythm.

If you blend these diagonal lines, a layer of color is created that is fine and pale. Here the color of the paper tends to darken the gradation though the color retains its warmth (**8**). One can see the dominant role played by the color of the paper. As you explore the medium of pastel, it is helpful to try out many colors of paper, studying the interactive possibilities. Remember, color reveals its beauty through its relative interaction. It is important to gain experience with the contrasts and moods the color of a paper can create.

MORE ON THIS TOPIC
- Mixtures with chalks and pastels **p. 42**
- Transparent mixing of two colors **p. 44**
- Opaque color **p. 46**

WARM COLORS, WARM RANGES

Choosing the Colors

When working with pastels it is a good idea to start off with a fairly extensive palette. The wide variety of tints and shades contained in a good pastel set is one of the medium's advantages. If you were using paint, these colors would have to be mixed.

Deciding which color you are going to use for the paper or support and limiting the color palette for a particular piece of work is a good exercise. A limited palette will assure chromatic harmonization of the work and allow you to create volumes without too many color choices, which at first can be confusing.

On page 8 we identified the range of warm colors. Next we will give you some ideas for the working palette. Except for example (**3**) (on gray Mi-Teintes 345) which starts out with few colors, all the other palettes presented allow you to work with numerous hues.

The choice of the pastels should depend on the dominant color of your subject matter. At the same time, interpretation is everything and pastel, with its chromatic possibilities, is the medium par excellence for the development of the artist's creativity.

Ordering and Colors

Putting the colors in order is a subject that will be dealt with in greater detail on page 68. In fact each of the color scales presented in this manual has logic and consistency. All the pastel colors that appear on pages 52 and 53, for example, are warm colors. They are classified by intensity, here moving from the lightest to the darkest, or from the least to the most intense.

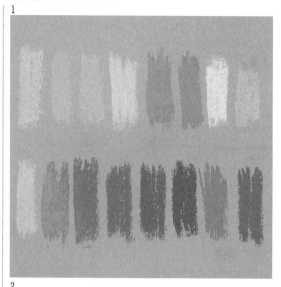

1

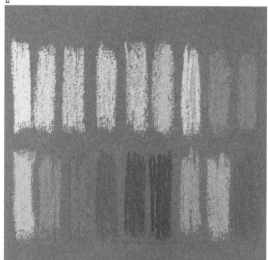

2

3

4

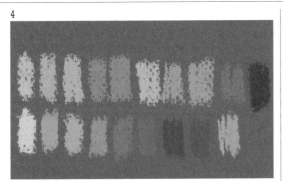

5

6

7

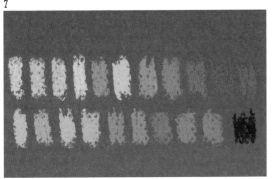

An Explosion of Color

All the colors that have been painted on these pages have a common chromatic characteristic: they are warm colors. The color interactions between the colors of the paper and those of the simple pastel chromatic scales creates an explosion of color.

Note the difference in mood and contrast on these warm backgrounds, ochre (1) or toasted sienna (2), of palettes that have very minimal differences. Notice, too, that similar tints of colors seem lighter on the darker background and darker on the lighter background. Once again we are seeing the effects of simultaneous contrast.

On a very intense background (4), Mi-Teintes 503 Deep Wine (5), the selection of pastels used creates an exciting shimmer of warm colors, unified by the paper itself. Backgrounds such as these offer very interesting color interactions and contrasts that tend to reveal the beauty of the colors used.

To provide cool backgrounds, two Mi-Teintes papers are used: the lightest (6) Mi-Teintes 595 Turquoise Blue and the darkest (7) 590 Ultramarine. Here we are playing with warm-cool contrasts, creating color harmonies by using complements with different color intensities. In the case of the ultramarine paper, a majority of reds and violets have been used. Yellows and oranges serve as highlight notes for shimmer and greater contrast.

MORE ON THIS TOPIC
· Cool colors, cool ranges **p. 54**
· Warm neutral colors **p. 56**

COOL COLORS, COOL RANGES

Choosing Cool Colors

The common characteristic of almost all the pastels that appear on these two pages is that they are cool colors.

Cool backgrounds interacting with cool pigments tend to produce strong color harmony, and yet it is a good idea to include small amounts of neutral warm colors to provide a vivid counterpoint. It is in this warm-cool interaction that the beauty of color can reveal itself. Introducing a note of color enriches with variation what might otherwise be a visual monotone.

For each of the background colors we have put forward a choice of possible palettes. Look at the two examples and compare their differences. One appears on Mi-Teintes 595 Turquoise Blue (**1**), the other on 590 Ultramarine (**2**), which here has a violet cast. These colors need not necessarily be used in the work. The color of the support will naturally influence your choice of colors initially, yet it is quite possible that the surface will be mostly covered, or that the color choices you make as you work your composition will play a more dominant role than the paper. The turquoise blue invites work with light or dark colors for contrast. The ultramarine lends itself to landscapes, with greens for the vegetation and the grays, blues, and violets that appear in the upper row of pastels for the sky and the atmosphere. The gray scale in (**3**) is warm, and appears here on a cool background. The interaction of warm against cool, particularly with a monochromatic scale such as this one, creates a quiet color harmony.

Sometimes the subject, a landscape at night for example, could lead to choosing a maximum of only 3 or 4 colors. Deep blue or violet papers are

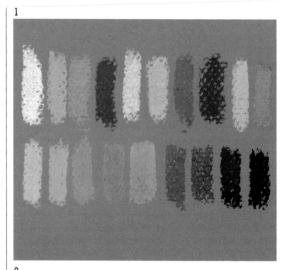

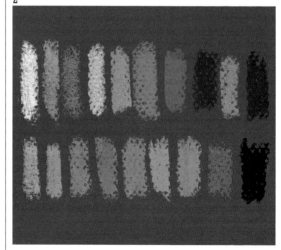

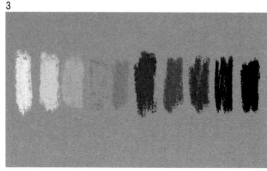

4

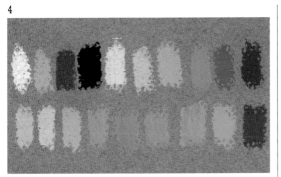

5

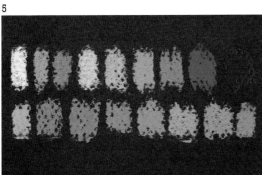

6

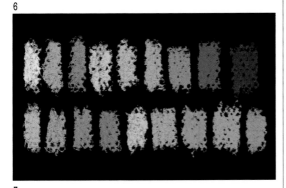

7

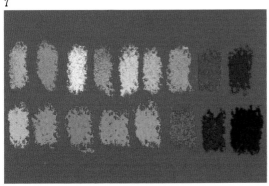

suitable for such evening scenes. Gradation, even of only a few colors, is still very important in order to create form, contrast, and the illusion of light. At least one of the colors should be very light to produce the right contrast with the color of the support and to distinguish areas of half light from those of complete darkness.

Contrasts

Well chosen cool colors stand out on any kind of neutral background. The next two examples are done on 429 Smoky Gray (**4**), a neutral color, and 503 Deep Wine (**5**), which is warmer.

Black paper provides a very dramatic background. Sometimes, a subject may suggest its use for the quality of the light it produces. A stormy night is one such possibility. Abstract color studies may be particularly beautiful done on a black surface (**6**).

The last example, again, plays with warm-cool contrasts. These colors are painted on Mi-Teintes 505 Bright Red (**7**). Complementary colors, here the greens, tend to shimmer or move, interacting with the red of the paper. A colored paper can also function as an intermediate value onto which lighter colors are applied, indicating a greater exposure to the light, while shadows are blocked in with darker colors.

Each subject will suggest color backgrounds that will best serve its representation. These color scales may give you some ideas for choosing colors to develop a particular composition. Variety of tones, contrasts, color intensity, and warm-cool juxtapositions will all serve to help you harmonize color.

| MORE ON THIS TOPIC |

• Warm colors, warm ranges **p. 52**

WARM NEUTRAL COLORS

Palettes for Skin Tones

1

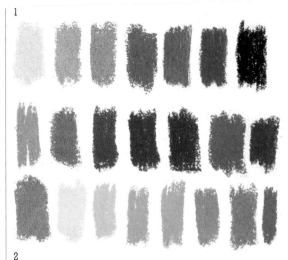

Pastel colors, as a pictorial medium, have an unrivalled capacity for creating darks and lights. This makes them particularly suitable for representing nudes, portraits, or dressed figures. For the representation of skin tones, more so than for other subject matter, the choice of your palette of colors is crucial to give credibility to form and volume. A portrait can be done entirely with cool colors, can show contrasts between cool and warm colors, or can use neutral colors, depending on the particulars of skin color. The coloration of flesh depends not only on characteristics of the skin itself, but on the light, and the colors surrounding it, fabrics, furniture, etc.

The figure can be worked on light, neutral, and dark backgrounds. Some excellent colors to use for figure and portraiture are Mi-Tientes, 100 Pale Green, 101 Lemon Yellow, 102 Blue, 103 Gold, 104 Lilac, 110 Lily, 111 Ivory, 112 Coquille, 120 Pearl Gray, 122 Gray Flannel, 130 Earth Red, 336 Light Ochre, 340 Flax, 343 Gray, 350 Rose, 374 Sienna, 384 Salmon, 407 Lichen, 470 Yellow, 502 Ochre, and 504 Rust.

Portraits and figures can effectively be done on any neutral colored paper. However, for character painting, or for dramatic and creative interpretations, you might try backgrounds of medium or very dark intensity.

In the example on a white background (1), a selection of some neutral pastel color has been applied. The variety is made up of warm colors and cooler colors. This range will allow you to develop effective and elegant darks and lights.

2

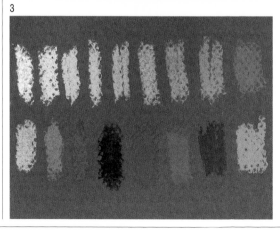

3

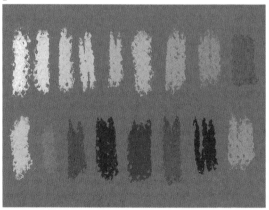

4

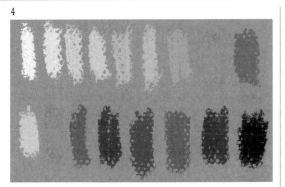

5

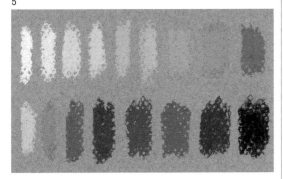

6

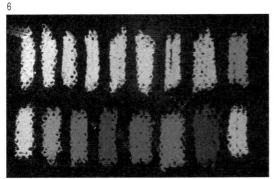

7

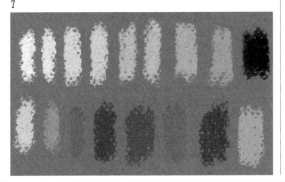

The Color of the Paper You Use

The color range shown on 502 Ochre paper (**2**) will allow you to work skin tones, using the dark colors for shadows and outlines.

On 503 Neutral Wine (**3**), the range of pigments shown are more dramatic. The light colors set the skin tones while darks are for shading. The darks that have very subtle contrast with the hue of the paper can be used for correction without having to rub out.

The 336 Light Ochre (**4**) and the Smoky Gray (**5**) show exactly the same choice of pastels. But the difference in the color of the paper modifies the general impression of the color of pastel.

On Mi-Teintes 425 Black (**6**) the explosion of color is dramatic. Color will, of course, have maximum contrast when viewed against black.

The color range used in (**7**) has a quiet, restrained look. The hue of paper is classic, traditional, Mi-Teintes 345 Cool Gray (**7**). Again, the light colors will block in skin tones while the darks will create shadows and edges.

Combination Possibilities

These are some suggestions for the palette and paper that work well for the representation of skin tones. But the possibilities are limitless, depending on the creativity of the artist. On page 72 we have noted some further color combinations that can be used to represent figures.

MORE ON THIS TOPIC

· Warm colors, warm ranges **p. 52**
· Cool colors, cool ranges **p. 54**
· Cool neutral colors **p. 58**

COOL NEUTRAL COLORS

Suggestions

Here is an example of a palette of mainly cool colors. Mi-Teintes 335 White paper is used, on the coarse-grained side (1). The natural quality of this range of colors will create a simple harmony. A subject such as a winter landscape on a rainy day could be worked with this limited palette. Whites added to these pigments will bring up the color and provide highlights, as well as building volume. The darker pigments will create your contrasts.

Achieving Your Goals

For general harmony using neutral colors, Mi-Teintes 112 Coquille, 502 Ochre, and 503 Neutral Wine will add warm-cool contrasts as well. These are pictured in examples (2, 3, and 4).

When the same selection of pastels is used on three different blue papers, intense rather than neutral colors create cool harmonies. See examples (5, 6, and 7).

On Mi-Teintes 435 Orange paper (8) a very different color effect is achieved using the same pastel pigments as in 5, 6, and 7. This orange is the complement of blue. The pastel hues now seem to shift toward their own complements, once again the effect of simultaneous contrast. Pastel is a medium that lends itself to leaving the color of the paper uncovered in places. For this reason the color of paper used plays a dominant role. The color of the paper will also determine the artist's color decisions in the process of working the piece. The paper's texture, too, will inevitably cause bits of the surface to show through, causing color interactions that enrich the medium's effects.

1

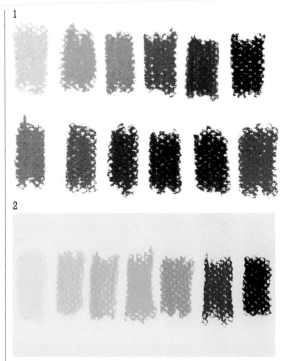

2

3

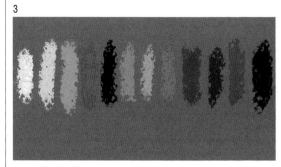

4

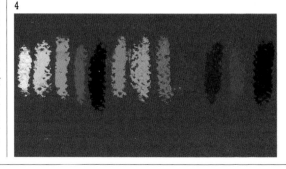

5

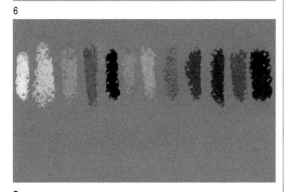

6

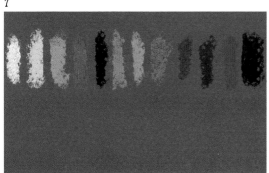

7

8

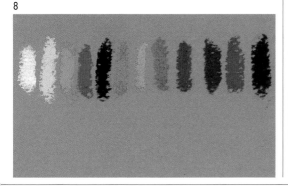

Grays

All the earth, broken, or neutral colors have a grayish aspect. A lot of grays are so subtle that it is difficult to decipher the color ingredients that have mixed them. But color perception is relative. It is by comparing several grays that you will clearly see the colors that have gone into many blues and greens for cool grays, reds and purples for warmer grays.

The range of neutral colors and grays that pastel manufacturers offer is very extensive, and these too offer many different possibilities.

A Complete Harmonized Range

A range of harmonized neutral colors can be quite complete in terms of including a full range of hues. It also has a more delicate look than full color. A warm palette, cool palette, and gray palette offer the painter three completely different and effective color palettes. Each of these palettes has been geared toward creating color harmony when used to work an individual piece. The understanding of color temperature is one of the most fundamental aspects of color. With experience this element can be handled with ease.

The contrasts between ranges also gives the painter a lot of possible combinations. These can be cross-worked within one composition, using combinations of warm and cool range, the warm range worked with warm neutral, the cool range and cool neutral, the warm range with cool neutral, etc.

MORE ON THIS TOPIC

- Warm colors, warm ranges **p. 52**
- Cool colors, cool ranges **p. 54**
- Warm neutral colors **p. 56**
- Grays **p. 60**

GRAYS

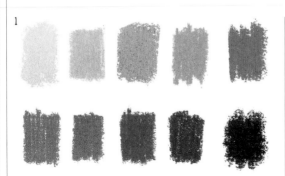

1

lightest grays are in the center. The circular toning blends two colors that occur side by side in places, while making opaque areas of single grays. This sample demonstrates how many shades of gray can be achieved.

On a white background, white only shows up as a tonal value if it is surrounded by another color, whereas on a colored background, white pastel creates a strong contrast. Look at the effect created by using white in the middle of the wheel (2).

Many Shades of Gray

Exploring the use of a range of grays is a good introductory exercise that helps you to get used to working with many colors. From the first charcoal sketches you did, you have some idea of how to analyze and evaluate tones. Continuous

opaque shading with a wide range of grays enriches the drama of chiaroscuro greatly.

This wheel (2) has been made with the grays that appear above it as a scale (1). The

2

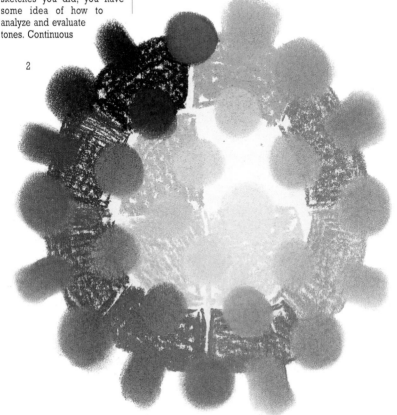

3

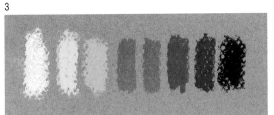

4

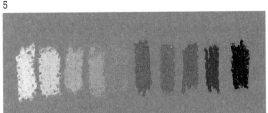

5

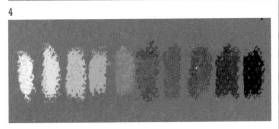

6

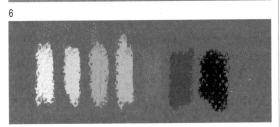

7

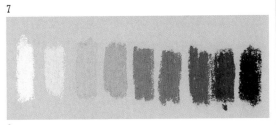

8

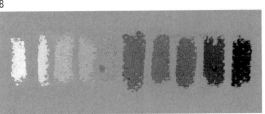

The Usefulness of Preliminary Trials

You can try to imagine the effect that using paper of a certain color will produce when you are using a particular selection of pastels. The result, however, can only be verified if you try things out before starting the drawing. Here are a few examples.

Two examples on neutral colors, with Mi-Teintes 429 Smoky Gray (**3**), and 502 Olive Green (**4**).

The next examples picture papers of different blues. There is a noticeable difference in the effects produced by the grays. Number 595 Turquoise Blue allows you to use any shade of gray (**5**). Not so with number 590 Ultramarine, which requires the use of pale grays blended with darker ones (**6**).

In example (**7**) the grays have been applied to yellow paper, creating strong contrasts. Strong contrasts are also created with this Mi-Teintes 453 Orange paper (**8**).

The grays read strongly on all these backgrounds with the exception of the Ultramarine Blue, which needs a paler average tonal value gray because it is so dark. All of the low numbers of Mi-Teintes paper, which have very pale colors, require dark grays. Number 490 Clear Blue requires the use of very pale and very dark grays. With each of the Mi-Teintes gray papers, it will take some exploration to find the scale of grays that will work best. Some examples of the Mi-Teintes grays: 120 Pearl Gray, 122 Gray Flannel, 343 Stone Gray, 345 Slate Gray, 354 Sky Gray, 426 Clear Gray, 429 Smoky Gray, 431 China Gray. As you can see, there is a wide range.

MORE ON THIS TOPIC

- Cool colors, cool ranges **p. 54**
- Warm neutral colors **p. 56**
- Cool neutral colors **p. 58**

ALTERNATING PROCEDURES. TWO COLORS

Skills and Technique

A pastel artist uses numerous combinations and alternates techniques while working on a drawing. With the many related materials and papers available, there are endless possibilities to use this medium creatively. The ease with which pastel can be worked and softened means that you can create many semi-transparent layers to achieve rich chromatic qualities. The skill of the pastel artist depends on observation of subject, the use of contrasts, understanding of color, and use of blending, all of which take practice.

Pastel is a medium that allows great creativity, especially with respect to synthesis and toning. Coloring or strokes are exercises in synthesis. Fading and softening, smudging, and coloring to alter pre-painted colors, are toning procedures.

Alternating Procedures

The pastel artist has a range of possibilities for mixing even when using only two colors, in this case a blue and a yellow.

By coloring very gently, overlapping the colors in places, you can obtain green (**1a**). See the result of using a finger to merge without muddying the color (**1b**).

You can also get green through optical blending as shown in (**2a**). Any type of stroke or pointillism (dotted) technique will do.

Blending zone by zone gives semi-opaque layers (**2b**). The result obtained if you color blue over yellow (**3**) is very different from that obtained by applying yellow over blue (**4**).

A line of blue placed to tone down the opaque yellow previously applied (**5a**), when smudged, adds a green cast (**5b**).

A line of yellow applied opaquely over blue (**6a**) shifts the blue toward green when blended (**6b**).

The direction of the blending or softening changes the result. The order in which the colors are applied is also very important. Here are some examples of blending that will

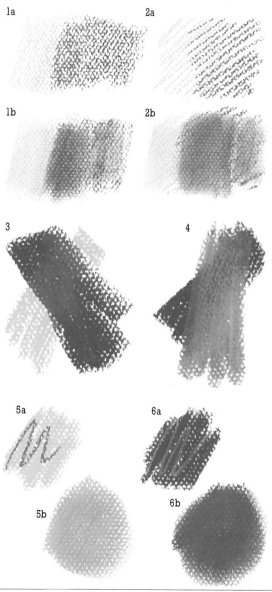

illustrate not only the chromatic qualities of pastels but also how they can be used to create fine superimposed layers.

In column A, opaque blue covers part of the yellow. In column B, opaque yellow covers part of the blue.

With a very opaque layer (in this case blue over yellow), one color almost covers the other (**7a**).

Another use of opaque coloring, yellow over blue (**8a**), produces a greenish tone in the border area.

In (**7b**), (**7a**) is blended from the yellow toward the blue. In (**7c**), you do the opposite, blending from the blue into the yellow.

Here the yellow is blended into the blue (**8b**). In (**8c**) it is reversed, blue into the yellow.

Study samples (**7b**, **7c**, **8b**, and **8c**) together. The order in which the colors are applied and the direction of the blending produces different colors and effects.

Working Expressively

All the previous examples are instructive. But now notice what can be done when shading is used expressively. The artist's hand was used to blend blue into the yellow (**9**) and here from the yellow into blue (**10**).

The circular blending in (**11**) hints at the way pastels can be molded with the fingers to create volume.

Note the artistic richness of these samples. The original color of the paper can still be seen through the pastel.

7a **A**

8a **B**

7b

8b

7c

8c

9

11

10

MORE ON THIS TOPIC

· Alternating procedures. Three colors **p. 64**
· Four colors **p. 66**

64

Alternating Procedures. Two Colors
Alternating Procedures. Three Colors
Four Colors

ALTERNATING PROCEDURES. THREE COLORS

The Method

To represent an object in, for example, a bright satin pink (as a reference—Pantone color 1777U), a range of pinks, say, pale pink, salmon, and carmine can be used.

Using the tone evaluation system on a white background, the color of the paper would be reserved to represent the brightest areas of shine. Pale pink is the lightest of these colors, salmon, the intermediate, and carmine, the darkest.

A pale gray could be blended in with these intense colors to depict reflections or the shadows in the folds of silk.

Alternating Procedures

Using these three colors (**1**), dark and light within color can be made by visually mixing the color with more or less of the paper's white. Here are some techniques: Each color may be applied in a thin or opaque layer. Applications can be blended or smudged (**2**). Two pinks can be superimposed using a transparency technique as in examples (**3**) and (**4**). In (**3**), carmine pink has been applied over pale pink. In (**4**), salmon pink over carmine. This overlay of color can also be blended (lower parts of examples (**3**) and (**4**)).

Using three pinks you can create a very transparent layer of color, which here has been blended and lifted out with a rag (**5**). Observe the effect of a few opaque strokes over the pale area (**5**). Next, strokes and crosshatching have been used (**6**). Optical mixtures can be achieved by crosshatching with two or more pinks.

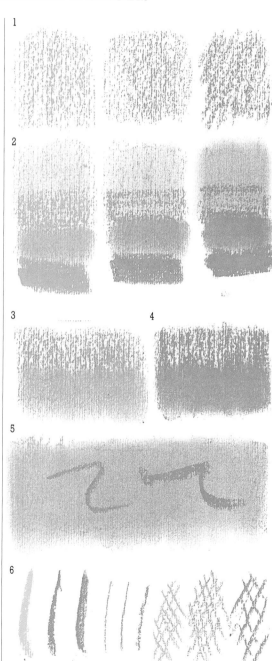

One instance of crosshatching can function very differently | from another depending on the direction of the strokes.

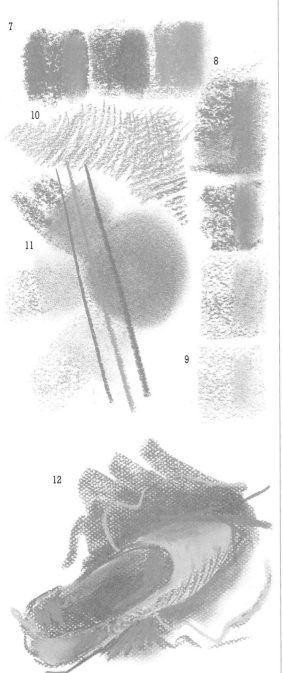

7

8

10

11

9

12

Deliberate Manipulation

Pastel technique involves color, outline, crosshatching, blending and softening, and building color and form in layers.

Alternating coloring and blending—example (**7**). Mixing through superimposing and softening (**8**). Applying color in thin layers and softening (**9**). Blending used to create a lighter tone; achieved using a clean cotton cloth.

Alternating coloring and lines in varying intensities, blending and softening, strokes over color or blurred color (**11**). In example (**10**) crosshatching has been used to create motion. By using a curved line the effect of rhythm occurs. Observe the difference between this crosshatch and the ones in example (**6**). By varying their direction and intensity, strokes such as these can depict the irregularities and creases in cloth.

On a Mi-Teintes 120 Pearl Gray paper, and using the same colors, we have drawn a pink silk ballet shoe (**12**). It is easy to identify some of the most common techniques. Transparent areas are worked alongside opaque areas; precise, bold strokes alongside other fainter ones. The carmine functions as shadow, pale pink functions as light. Blending and softening and changes in tone all serve to build the volume of the shoe.

Much of the beauty of pastel lies in its freshness of color. The example aims to convey an understanding that the strength and freshness of pastels lies in starting off on the right foot. Above all, one should never press too hard when working with pastels.

MORE ON THIS TOPIC
- Alternating procedures. Two colors **p. 62**
- Four colors **p. 66**

FOUR COLORS

A Whole Range of Possibilities

Continuing the exploration of the immense range of possibilities that the use of pastels offers, we have in this next example presented another group of potent colors, particularly for the construction of volume, and to experiment with contrasts. This range is made up of four colors, useful on Mi-Teintes 425 Black paper.

Each color has been applied in an opaque patch (**1**).

Opacity allows for generous blending (**2**).

The color and texture of the paper can be seen through the lightly applied color (**3**).

The faint color can be blended or further lightened with a rag (**4**).

You can also tint and lighten darker colors with your lightest color (**5**, **6**, and **7**). In column A color has been applied directly from the pastel stick. In column B a line of a light color has been added to brighten it. Column C shows the result obtained by blending.

You can also darken and shift colors toward other hues by adding and blending in the same way (**8**, **9**, and **10**).

In the color patches pictured in examples (**5** to **10**) we have been able to produce a beautiful range of blended variations.

The grading can be worked to appear opaque or semi-transparent.

In example (**11**) the colors have been applied in an ordered gradation starting with the lightest and finishing off with the darkest, using diagonal lines (**11**). Below it is a semi-transparent tone done with blending (**12**).

Next, two colors have been placed side by side and, by applying them opaquely, and overlapping the color, two other colors have been produced (**13**).

Next you can see the impression of volume that has been created by blending them (**14**).

The contrast between these blocked-in colors, and lines drawn into them, is seen in

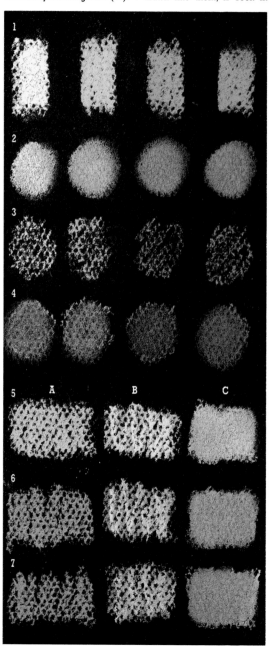

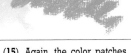

(15). Again, the color patches have been graded. A similar effect has been created in (16).

Choosing Procedures

These examples offer a variety of approaches, yet it is the pastel artist who decides which ways of working best serve his or her goals. Each approach offered serves the creation of form. Colors need to be mixed and blended to give the impression of volume and contrast. Still, each artist will have his or her own interpretation of these methods.

Not all the colors will need to be blended or lifted; some will remain unworked and fresh, without any manipulation at all. Some lines will be outlines, others crosshatch lines, still others will block in color, be blended, and lost.

Having a Vision

Try to imagine or picture the way you'd like your piece to look before you start. Doing a sketch, blocking in contrasts and movement, will establish the foundation of the piece. The rest is the process of working the piece, developing and interpreting your subject stage by stage, until the image is strong.

Summary

The fine color adjustment comes from continual study of your subject matter. Colors will need adjustment as they are blocked in and worked. The chromatic structure of your work will be achieved by correcting and reworking, rubbing out and blending, blocking in and working the color, layer after layer. Fixative will help when the material gets too saturated and needs binding in order to be reworked. As you work, undo areas that aren't working visually. If the contrast is too strong, use blending to tone it down. Remember, as in drawing or painting with any medium, areas and elements nearest to the artist show more precision. Areas that are farther away are more general. Therefore, in each plane the importance given to blending and lightening color changes.

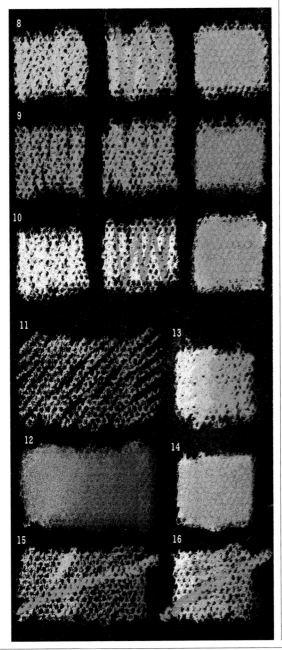

MORE ON THIS TOPIC

- Alternating procedures. Two colors **p. 62**
- Alternating procedures. Three colors **p. 64**

HOW TO WORK

Organizing the Colors

Let us suppose, by way of an example, that you have decided to work on a gray-green paper. The choice of palette will be made in order to create a particularly vivid look.

Against the neutral green ochre background, the applied pigments create a burst of color (**1**). The organization of these colors is established, first, by separating warm colors from cool. Then, the warm colors have been further divided into two groups: lighter and darker. This is not the only possible way of organizing colors. Each pastel artist finds his or her own way of organizing colors. But this is a starting point. In the example at the bottom of this page the hue, its possible shades and tints, and the effects of shading are pictured. This is the basis of palette organization.

However you decide to organize your palette, separating warm colors from cool is important, as warm colors will function as areas of light, while the cool colors will function as shadow.

Two Colors Always

The pastel artist must learn to think of one color in relation to another. Color changes depending on the colors that appear near it—simultaneous contrast again. For this reason color is worked and reworked on the support as the artist seeks a particular effect. The following are examples of two very different starting colors, and ways they can be altered by mixing.

A red for darkening a pink (**2a**). A blue for darkening a lighter blue (**2b**). A blue for cooling down a pink (**2c**). A blue for darkening a red (**2d**).

1

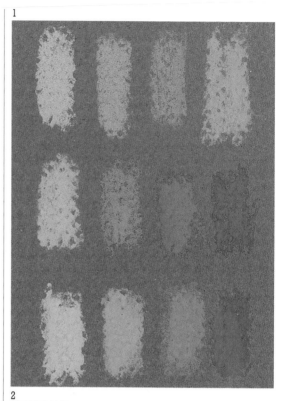

2

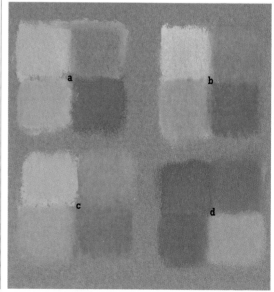

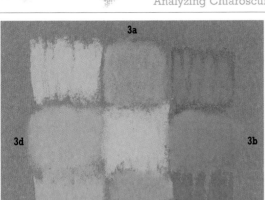

the color that is used to create shine and reflections.

Note example (**3**). At each end of the top row are pure colors. A blend of pink and carmine is tinged with an off-white (**3a**). The blending of carmine and blue is lightened and changed with the white (**3b**). In the bottom row, dark blue and light blue (at either end), have been lightened with off-white (**3c**). A blend of pink and blue, lightened with the off-white (**3d**).

Blocking and Crosshatching

By alternating blocking and crosshatching lines, contrasts can be produced, effects that can be made more precise if further worked. See the contrast between the cool and warm colors, traced over warm blended colors (**4a**). The opposite effect, where warm and cool colors are drawn over cool blended colors (**4b**).

Doing It for Real

The practice patches are useful for understanding a procedure or testing a contrast. Painting is another matter. Here is an area of pastel work that consists of only three colors. Several techniques have been used to achieve this expressive effect (**5**).

MORE ON THIS TOPIC
· Analyzing chiaroscuro, dark against light **p. 70**

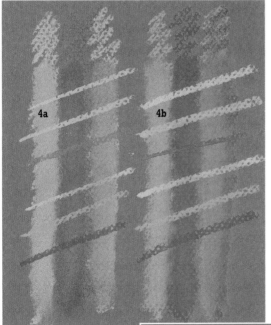

One Color More

Mixing is done by superimposing layers of color and blending. Here, a third color is added to introduce subtle distinctions. In example (**3**) the lightest color has been used for lightening the other colors in this grid. It serves to unify and harmonize the whole. It is also

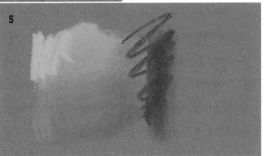

ANALYZING CHIAROSCURO, DARK AGAINST LIGHT

An Example

This work is done on light blue paper, using four warm colors, plus white and a blue.

The light colors are some of the brightest colors on the palette. The mixed colors are made by superimposing a lighter color over a darker one and vice versa.

In these examples, circular blends are done with a fingertip (**1**). Notice the difference in color, depending upon the order in which the pigment has been applied. Even on blue paper like this, the difference stands out.

The bottom row ranges from blue to purple. The blue, the only cool color in this range, is used to create shades and darken, cooling down the other colors (**2**).

The color of the paper is cool. Any uncovered space on it will be visually incorporated into the work as a lighter blue than the ultramarine blue that is applied to it. The blue paper will affect the work in general, particularly in thin layers of applied color.

Another Example

In the next example (**3**), the coolest color is a red violet. Here deep colors and strong contrasts have been avoided. There is a lovely harmony here, with a completely different feel to it. The color of the paper is Mi-Teintes 352 Deep Rose.

Nine possible mixtures have been pictured, each using two colors (**4**). Any tone evaluation done will need to be based on the dark-light relationships between these particular colors. Visually assessing these mixtures as they appear together

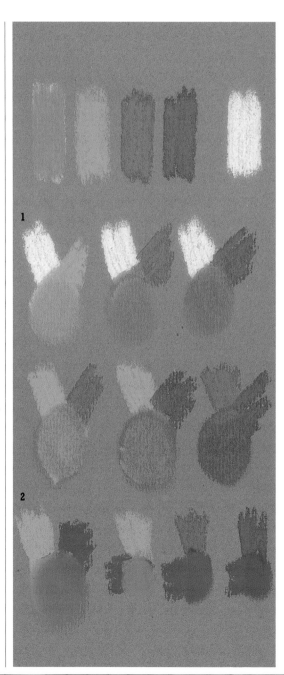

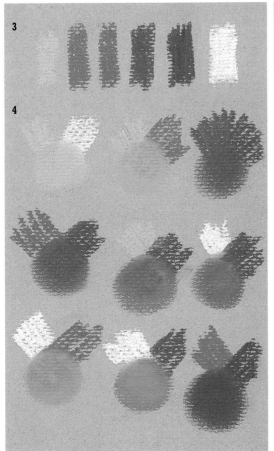

allows you to see which ones read as the warms, and which as the cools. You can easily contrast the temperature of a shadow.

The deepest violet is reserved for the darkest areas. In addition to functioning as shadow, this color is also used to darken and give variety to the other colors.

The color of the paper is a medium tone that can be utilized to construct form. The possibility of incorporating clear spaces of paper into the finished work increases your palette and can give a generally crisp appearance.

Organizing Your Palette

It is a good work habit to organize the colors of your palette according to depth of color and tone. An empty pastel box that has paper or foam dividers can be used for this purpose. Arranging and organizing your colors in this way will help you create organized color ranges in your drawing. Pictured here is an organized application of opaque color, creating a range to work with, (**5**), and the effect of blending them (**6**).

When constructing volume and form you will need to apply your color in darks, mediums, and lights. The practical work of coloring will be aided by classifying your pastels in advance. Careful organization makes locating the colors you need easier, even revealing possible color interactions that may work for your composition.

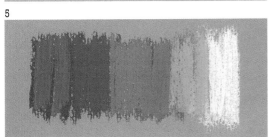

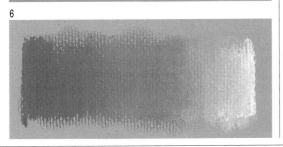

MORE ON THIS TOPIC

· Alternating procedures. Three colors **p. 64**
· Chiaroscuro technique in practice. Drapery **p. 74**

A PALETTE OF FEW COLORS FOR FLESH TONES

Establishing a Method

You can draw a nude on Mi-Teintes 503 Neutral Wine paper, using just five different colors. The range of colors including the support is warm. The background has also been chosen to provide contrast, because it is much darker than the range of colors of the palette. Off-white pastel will function as the lightest.

The examples that appear on these two pages enable us to see some possibilities for physical mixtures and optical textural effects. There is an endless range of these possibilities.

The Essentials

The first five colors, applied in opaque blocks, will be needed to depict areas closest to the artist (**1**). Unblended colors correspond to greater proximity.

Next, the colors appear softened (**2**). An opaque application of pastel that is partly blended creates the impression of volume. Remember, less exactness of detail implies greater distance. Blending only part of the outline fades the image.

Above these blended areas are the colors we started out with (**3**). With these colors we can create warm-cool chiaroscuro or contrasts. Here are examples of warm shadows (**3a**) and lighter cooler shadows (**3b**).

All of the colors can be blended and mixed, each one with one of the others. Here pale ochre is tinged with cool pink, the darkest color in this range of pastels (**4**). Blending should be expressive in quality, particularly when drawing the figure.

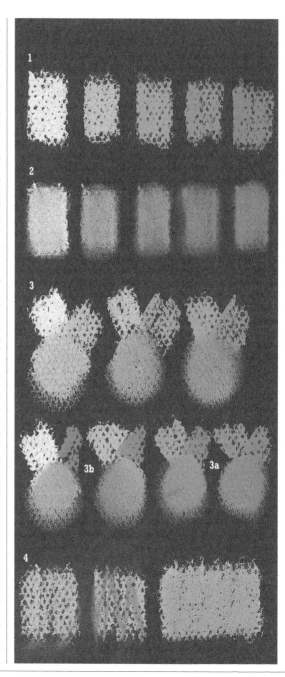

Analyzing Chiaroscuro, Dark Against Light
A Palette of Few Colors for Flesh Tones
Chiaroscuro Technique in Practice. Drapery

73

It is directly related to the general feeling of the work.

Here the colors have been placed in order and used opaquely (**5a**). In the lower strip (**5b**), the colors have been blended together, taking care not to muddy them. This range of color will express the lights and darks of skin tones and suggest areas of skin in the light and in shadow.

Blending and Outlining

With these examples (**6**), you can see that blending in circles, with the tip of the thumb, from the darker color into the lighter one, produces a delicate effect of texture that contrasts with the color of the paper. Direction and modulation of the blending play an important role when depicting form.

Here blending has been edged with curved tracings that form outlines, in each case done with the darker of each pair of pastels. Outlining used in portraits and figures is generally broken and intermittent. It strengthens edges and contains the form and is one of the most common practices of artists working in this medium.

This example provides a typical illustration of coloring and line techniques used when drawing the human form, a common application of the technique of blending. Pale coloring on this dark paper conveys shadows. The paper itself can be used to convey the areas of deepest shadowing (**7**) when pale colors are contrasted with darker paper. Outlining used with blending can modulate contrasts; reducing their severity.

In the next example, crosshatching and coloring techniques have been alternated (**8**). This mosaic demonstrates that each type of smudge creates a different effect. A work developed in linear strokes or crosshatching used to build form, will tend to have motion and rhythm.

MORE ON THIS TOPIC

• Warm neutral colors p. 56

CHIAROSCURO TECHNIQUE IN PRACTICE. DRAPERY

Exercise

Drapes are a good subject to practice with as an introduction to chiaroscuro, or the working of light against dark. Fabric is often used as a background for still lifes or nudes and appears as clothing on dressed figures. Working in chiaroscuro using drapery allows the study of this technique at its purest. Before working with drapery with pastels it is advisable to do a study, in this case using only sanguine. To begin it is enough to sketch the placement and basic tone organization (1). A sketch done in sanguine on pastel paper provides the perfect framework on which to

work the pastels.

Start by drawing the dominant lines of the folds. Take care that the direction in which the cloth hangs is accurate. As

Arrangement of the piece of cloth. The view against the light highlights all the details of the folds producing shadows but with no harsh lines.

you work over this sketch with pastels your initial lines may blur or disappear due to blending and softening. These should be replaced with your colors as you develop the pastel painting over the sanguine underpainting. Both these media are perfectly compatible. Working in depth using only sanguine, however, will allow you to study the forms and motion of the cloth, greatly increasing your understanding of the elements of light and shade. Studies such as this one will provide the knowledge of dark and light you will need to transfer to a broader palette.

1. A sketch done for placement and tone analysis.

2. Drapery depicted in sanguine.

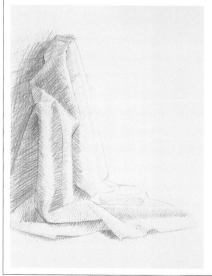

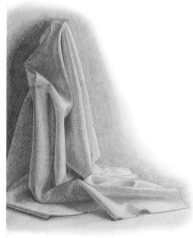

A Detail in Close-up

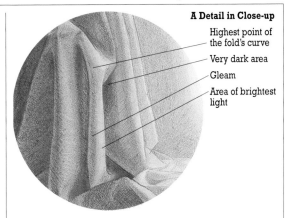

Highest point of the fold's curve

Very dark area

Gleam

Area of brightest light

Advice

As a general rule, it is best to sketch your first strokes very faintly, until you are sure of position. Any correcting of placement can then be done without marring too much of the surface or affecting the paper's adherence capacity.

Below are two works by pastel artists. Note the almost photographic effect Fuentetaja achieves. This beautiful work by Domingo Alvarez shows his soft touch and exquisite sensitivity with pastel. Notice the lights and darks, the chiaroscuro, in the clothing of both figures.

In each work, the shadows have been modeled in the direction the cloth is falling. Particular features have been depicted with great skill. In the sleeves, for example, the shadows emphasize the hollows of the folds. The coloring in areas where the greatest amount of light falls has been contrasted against darker areas, creating strong brights.

Shading the Folds in Drapery

Many types of cloth give off a gleam when light shines on them. Thus, in addition to the hang of a fold, reflections appear in areas of shade. The depiction of this gleam or brighter tone in the midst of a shadow denotes its most three-dimensional area.

The superrealism of Fuentetaja.

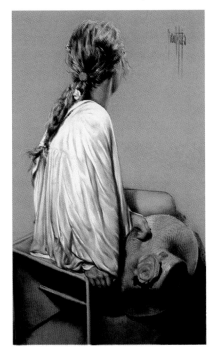

Domingo Alvarez is a master of chiaroscuro who uses fine, subtle shades.

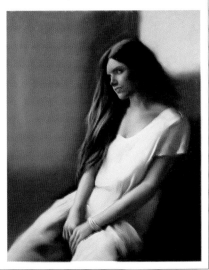

76 Chiaroscuro Technique in Practice. Drapery
Contrasting Tonal Values
Using Color to Convey Dark and Light

CONTRASTING TONAL VALUES

Constructing Tone Contrasts

Here the artist Francesc Crespo tackles a drawing of a nude in pastels. Blending and mixing colors as well as strong contrasts characterize the way he works.

The figure is seated gracefully. The dark background and lighting produce interesting contrasts. To begin the charcoal sketch, the darker areas are blocked in. Orange ochres, sanguine, and olive green for subtle shading are used for lighter areas of the figure. These colors are chosen to reproduce the colors the artist observes. The drawing is worked area by area, based on observation. The artist alternates coloring and blending with his fingers.

Volume is built by working on the lighter areas first and passing progressively to the darker zones;

The model is seated in a graceful pose.

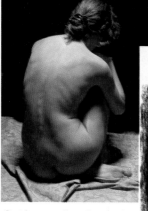

Pastels are used to color over the charcoal sketch, which has been blocked in with strong dark strokes and patches.

MORE ON THIS TOPIC
- Chiaroscuro technique in practice. Drapery **p. 74**

the patches of color are applied with the flat of the pastel. The desired color does not always come directly from a stick. You might, for example, have colored a salmon pink next to an orange and had to resort to a fine layer of light olive green, which, after blending, produces the subtle reflection you were seeking.

After the artist has developed the light areas, he begins to shape the darker areas with umbers and grays.

Using this area-by-area, step-by-step sequence of development, blending the colors with the fingers, a marvelous chiaroscuro is created.

Even from the initial sketch, the looseness of the charcoal allows us to block in and work the darker zones with vigor. Blending charcoal with pastel colors does not dominate color as using black or dark gray

Light colors are then applied.

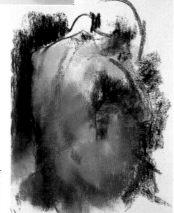

Application of coloring is alternated with blending.

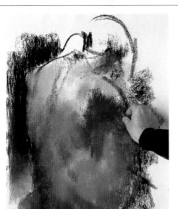

Umber is worked into the darkest areas.

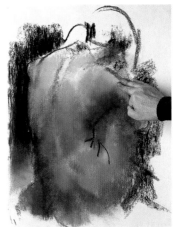

Grading is done very smoothly, avoiding sudden changes of tone.

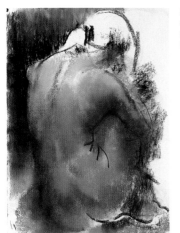

Light and shade are further defined.

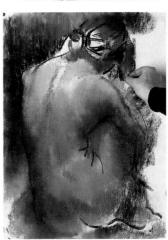

Details of the head.

pastel would, but modulates it instead, allowing it to function as shadow.

The forms and volumes of the figure and its flesh tones emerge gradually, as does the treatment of the background.

The artist introduces notes of vivid color for the hair and the surrounding drapery. The figure grows beautifully, as if out of the very texture of the paper itself, which is exposed and visible in places, giving the work a rich atmosphere.

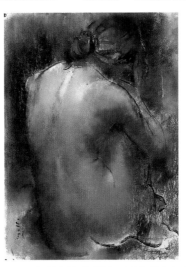

Tonal contrasts and blending colors work together. Pastel has a great capacity for conveying powerful chiaroscuro effects, that is to say, strongly contrasted darks against lights and lights against darks.

Final blending, modulation of tones, a strong finished drawing.

USING COLOR TO CONVEY DARK AND LIGHT

The Colorist Version

When pure color is used directly, shades and tints, warms and cools, earth colors and saturated color, always applied relatively ungrayed, then you may say you are working as a colorist. The secret of such a direct functioning to represent shadows, darks, and lights lies in close and careful observation of the hues that exist on the surface of your subject. Then it is a matter of matching those colors with your pastels.

Form, volume, and atmosphere are depicted through color. Achieving the effect of light and shade rests on contrast between intense light and darker colors, and warm and cool colors. Volume may be portrayed by means of the contrast between complementary colors, which tends to create impact and vibrancy.

When pure color is used to create form and space (rather than using black and grays), a lot of visual color mixing will take place.

Some colorist painters don't use blending at all. Yet others achieve vibrant color effects with its use.

A colorist's representation of subject matter is, by definition, open to expression, personal interpretation, and the artist's sensibility.

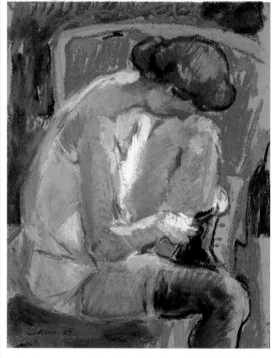

A contemporary pastel painting. Color is used with little blending once it has been laid down. The color interactions convey light and shade. Woman putting on stockings. *Teresa Llácer.*

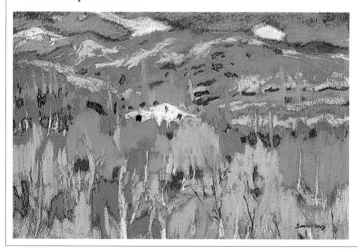

Landscape. *Ramón Sanviçens. The vibrance of these colors rests on the warm-cool color interactions.*

A COLORFUL STILL LIFE

Step by Step

A still life is always a good subject for thoroughly developing the volume of its individual objects. But a still life developed with color has particular requirements. Here is the step-by-step process of this still life's development.

1. The objects are blocked in with pure, bright colors.

2. The shadow of the teapot is further developed in blue, the shadow of the pottery in red.

3. The contrasts are developed by using complementary colors: the orange of the table with the blue of the glass, the reds and greens in the apple.

4. The color areas have a linear treatment that boosts the vibrant effect between the colors and their contrasts while increasing the effect of volume.

5. The painting presents contrast between direct and nearly direct complementary colors, orange and blue, red and green, orange-ochre and violet.

In each phase the color structure is further developed. Each color is used for its bright, interactive value, keeping the color of the piece high.

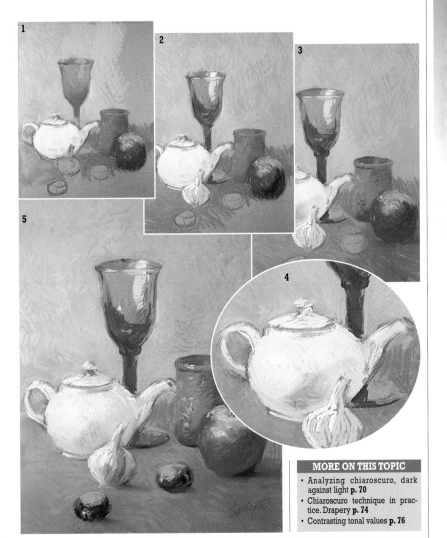

MORE ON THIS TOPIC

- Analyzing chiaroscuro, dark against light **p. 70**
- Chiaroscuro technique in practice. Drapery **p. 74**
- Contrasting tonal values **p. 76**

OIL CRAYONS

What Is Interesting About the Medium

Oil crayons are a greasy medium that can be used in conjunction with any dry medium. They behave differently than dry media, however, and require some explanation to understand their potential and use.

Like pastels, they come in stick form and can be used for drawing and blocking in color. Blurring their lines and blending their color areas requires a firmer touch, as they are not powdery but oily. The fatty compounds melt with friction. The warmth of your fingers is one good way to melt them and make them workable. Using a cloth is another way to smudge oil crayon and spread color.

MORE ON THIS TOPIC
• Oil crayons and pastels **p. 82**

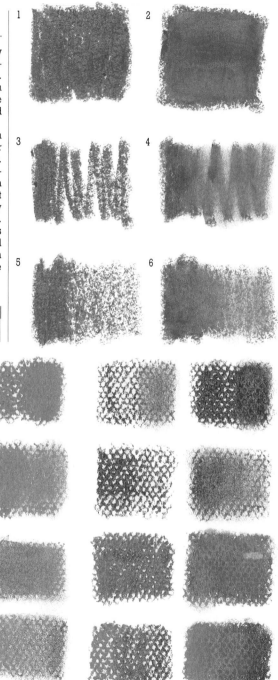

Oil crayons are not as delicate as dry media, since their binder makes them much more stable.

They can be worked somewhat more precisely than the dustier pastels.

Sample of blue oil crayon applied to a surface (**1**). Observe the smooth, opaque quality of blending (**2**).

Color applied with strokes (**3**) looks like this when blended (**4**). Even with friction the strokes remain intact, while the blending has created transparency. The oil crayon's adherence to the paper is the characteristic that distinguishes it from pastel and chalk.

An oil crayon can be worked lightly, allowing the color of the paper to show (**5**). Note the effect of blending (**6**).

Areas worked with two wax crayons. Samples of faint and opaque coloring (**7**). The right side of each square has been blended.

The graded areas of each color can be blended into the white of the paper (**8**).

Both colors can be superimposed in thin or opaque layers and be visually combined (**9**).

The grading between both colors can be faint or opaque and the resulting shades blended (**10**).

Observations

When working with oil crayon, it is possible to use *sgraffito* lines, which scrape away color to expose the paper as well as other colors, to create a wealth of shade and texture (**11**).

White oil crayon can be used to reserve areas when used with wet media (for example water color or ink). Here it is used with other oil colors. The white oil crayon reduces the intensity of the color applied on top (**12**) and reserves part of the color of the support, which is then recovered using *sgraffito*. Oil crayon is a medium that enables you to create textures (**13**). A lot of white can be used when painting with oil colors to create tints and brights (**14**).

Here oil crayon is used to produce strong contrasts to build volume (**15**), or to create an abstract effect (**16**).

11

12

13

14

15

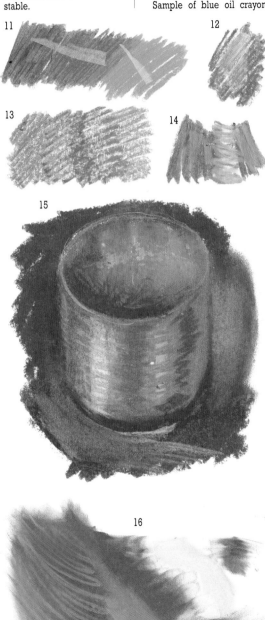

16

OIL CRAYONS AND PASTELS

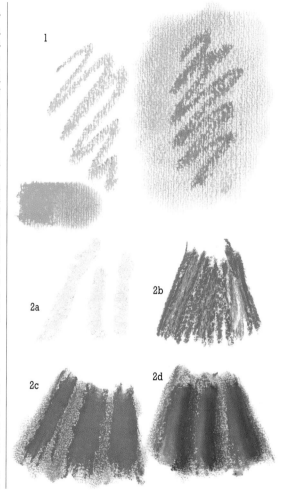

Binders

The greasy waxes and oils in oil crayon are compatible with dry media, such as charcoal, sanguine, chalk, or pastels. Using an ochre oil crayon and an orange pastel, individually shown on the left side of (**1**), you can create the effect on the right by painting over the oil with the pastel. Where there is oil color, the oil and pastel accumulate; oil repels water-based media, but binds dry ones.

Next we can draw the fold in a piece of cloth using this mixed technique (**2**). You can start by doing a few strokes in white oil crayon (**2a**). Color over it with a carmine pastel (**2b**). The effect is produced by blending in the direction of the folds (**2c**). With a violet pastel, add some strokes to represent the shadows in the folds, and blend with your finger (**2d**). The final effect creates form.

Textures

Alternating oil crayons and pastels, you can achieve very interesting textures. Here the underpainting is done with a white oil color base (**3**). Oil crayon and pastels are applied over it.

Choose colors in the same color range to work monochro-

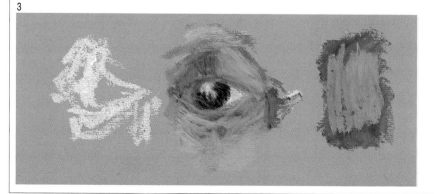

4

matically. Begin your drawing with pastel, and follow the pastel lines with oil crayon. Alternate oil crayon with pastel in this way, painting and drawing to reproduce your subject. Working this way will create thick impastos.

Reserves and Subdued Colors

If you first color the support of a painting with white oil crayon, the colors you paint on top, pastels and oil, create opaque color, as they are in contact with the oil crayon rather than the surface of the paper.

This small study of pavement has been done on a foundation of white oil crayon, then worked with a mid-gray pastel, and more white crayon (**4**).

Reserving and *Sgraffito*

Using white oil crayon as a base enables you to reserve areas to be recovered through *sgraffito*, or removing color. In example (**5**), the light folds of the handkerchief, the stitches, seams, and edges have been recovered using *sgraffito*. By way of these examples, you can see how the oil crayon works when pastel is applied on top. Remember, pastel pigment will be held by the binders in oil crayon. The mixing of these different media, therefore, has a particular look.

A landscape at night, as seen from a distance, is done using oil pastel and pastel, (**6**). The tree shapes and low vegetation are drawn with a violet oil crayon (**6a**). The sky is colored with white oil crayon (**6b**). Ultramarine blue pastel is blocked in over it for the sky, the lower part, with a darker blue (**6c**). Note the effect achieved by blending the colors, pastels and oil (**6d**).

MORE ON THIS TOPIC
• Oil crayons **p. 80**

5

6a

6b

6c

6d

CARBON OR GRAPHITE PENCILS AND PASTELS

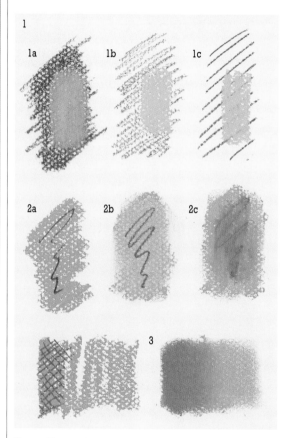

see some examples of its use.

Observe the effect of applying a pink pastel over areas shaded with graphite pencil (**1**).

Notice the quality of the color, effected by the dense shading with graphite pencil (**a**), fainter shading (**b**), and shading over heavy, widely spaced strokes (**c**).

The following examples show the effect of applying the pastel first (**2**). First graphite pencil strokes are applied over an opaque coat of pastel, another shade of pink (**2a**). In (**2b**) the graphite pencil is applied over a blended area. Notice the effect of blending the opaque pink together with heavy strokes of graphite pencil drawn into it (**2c**).

Graphite pencil is used to draw crosshatching over an area colored with the same pink (**3**); when blended, an attractive grading effect is produced.

Use

Graphite pencil and pastels are used together when sketching, or when producing particular textures. But such sketching

How to Proceed

When using graphite pencils and pastels together there are several things to consider, depending on the type of support used. In general, pastel won't easily adhere to areas shaded in carbon or graphite pencil, particularly if the pencil covers the whole of the surface of the paper, as the material itself tends to repel the chalk. You will get better results if you apply the pastel first, or if there are areas of the paper the pencil has not touched. After a brief introduction to the applications of this technique, we will

5

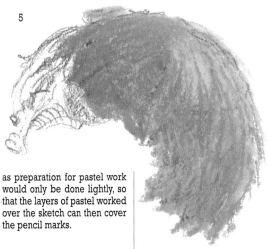

MORE ON THIS TOPIC

• Colored pencils **p. 86**
• Colored pencils and pastels **p. 88**

and describe the movement and fall of hair with the direction and density of its lines.

Graphite lines can, for instance, sketch the structure of curls and the three-dimensional masses of hair, which can then be developed in pastel.

Coloring and Lines

In this quick sketch, the graphite pencil work has not been covered completely (**6**). The techniques of coloring with pastels, while using pencil shading and lines, exist side by side. With a graphite pencil you can draw very fine lines, much finer than with pastel.

as preparation for pastel work would only be done lightly, so that the layers of pastel worked over the sketch can then cover the pencil marks.

A Quick Full-color Sketch

Here is an example on newsprint paper, a good sketch surface (**4**). On the left of the sketch one part of the fence has been left uncolored to show the structure. A quick pencil sketch is done first, laying in tones, based on observation of subject. Enough white of the paper is exposed to hold the soft pastel colors, applied directly on top of the pencil.

A light coat of fixative can be used over the graphite, which will increase the graphite's capacity to hold the chalk.

Creating Texture

Here a base has been sketched with a graphite pencil and worked over with pastels (**5**). The graphite establishes a stable underdrawing that can give the impression of volume

6

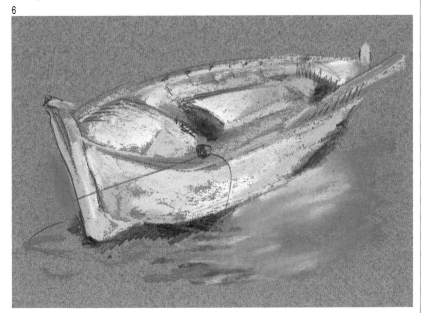

COLORED PENCILS

Superimposing Layers

Colored pencil is another excellent medium for drawing and color mixing. Conventional, water-resistant colored pencils enable you to build form and develop drawing skills. Still other techniques are required for using watercolor pencils. But here, we will explore the use of colored pencils that have a waxy binder.

A tonal range can be developed in any color, for example blue (**1**), by varying the pressure on your pencil.

The possibilities of mixing can be appreciated if you make a chart using the primary colors, seeing the mixtures they create where two colors overlap (**2**).

Layers of different colors can be superimposed to create other colors. With some practice and experience, colored pencils will mix a full spectrum of deep, rich hues and tones (**3**).

Using yellow and blue, you can create a range of greens. With practice you can create a gradation of green by superimposing two gradings. First color with blue, then apply the yellow over it (**4**). To achieve different shades you have to superimpose layers of each color (**5**). First they should be faint for

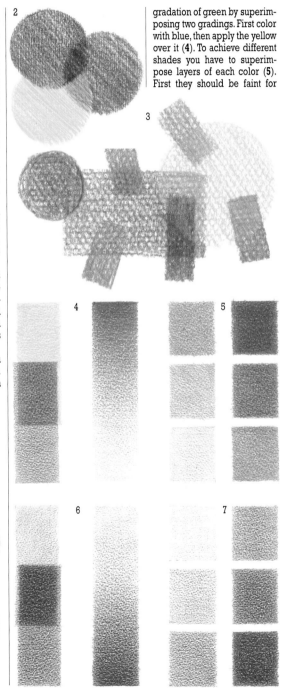

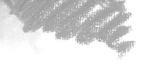

the lightest shade, then gradually increase intensity for the darker shades.

From primary red and blue, you can create a gradation of violet (**6**) and a range of tones of blues and blue violets (**7**).

From primary yellow and red, you can achieve gradations and (**8**) tonal values of oranges and reds (**9**).

When the three primary colors are mixed together in varying proportions you can create beautiful ochres and earth colors (**10**).

Neutral grays, which are also obtained by mixing the three primary colors, here are shifted toward warmth by adding some yellow (**11**).

Control

Defined edges can be achieved by controlling your strokes. Diffused coloring requires a light touch and some practice. Though colored pencils can be used in very simple ways, they are a sophisticated medium. With time and practice they can be used with great skill and technique. Colored pencil can be used in very pale overlays, building colors slowly. Control is exerted by the pressure of the stroke; deep rich areas can be built in this way, as well as strong volumes and forms.

These pencils can also create crosshatching, which has its own look and form-building capacity.

MORE ON THIS TOPIC
· Colored pencils and pastels **p. 88**

COLORED PENCILS AND PASTELS

Their Coloring Properties

It is not unusual for an artist to work by alternating colored pencils with pastels. However, the properties of the pencil require a certain amount of knowledge of the medium in order to successfully use them with pastels. The following examples illustrate the potential of this mixture.

A pale sienna pastel is applied over a layer of blue pencil (**1**); in the area that is not blended, the blue is visible through the pastel color.

Where the pastel has been softened and worked, the effect of the blue underlayer can still be seen as a darker area. The mixture of these media is done by superimposing layers. The layer of pencil with its wax binder is more difficult to soften than the pastel, a quality that adds a certain look or ambience to the work.

When we color with two pencils, superimposing blue over violet, the color produced at the overlap is a mixture of the two. The added layer of sienna pastel superimposed over the pencil colors produces an earth tone and delicate nuances (**2**). Notice the way the violet and blue shapes show through the ochre, maintaining their edges.

In the next example, two pastel colors, gray and violet, are laid down (**3**), and colored over with blue and purple pencils. Notice the visual effect this has with the soft, graded pastel (**4**). When colored pencil is used with pastel the work takes on a particular look, moody and beautiful.

1

2

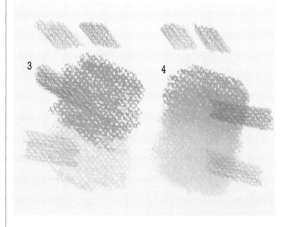

3

4

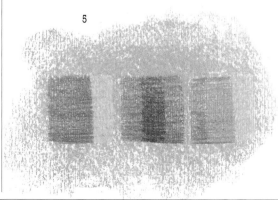

5

Limitations

It takes practice and time to manage the technique of alternating these two media. The surface of the paper quickly becomes saturated with both media. It is good practice to try out the effects on a scrap of paper first. Because of this saturation factor the application of too many layers should be avoided. It is better to overlap layers of pale colors. The colors darken quickly as layers of these two materials are superimposed. Achieve a colorfast effect with pencil over which the background has been blocked in with pastel (**5**).

Details and Shades

Look at the following example. It is a depiction of woven wicker, an area of basket (**6**). Three shades of blue pencil have been used. On the right side of the drawing, color has been overlaid with neutral pastel color, allowing all the detail of the weave to show through.

In this way colored pencils and pastels can be alternated in the same work. With a blue pencil and a pale ochre pastel we've here used areas of color, shading, and line drawing techniques, one superimposed on the other (**7**) in alternate layers. The white of the paper, which shows through the colored pencil, juxtaposed with areas of pastel overlays, enriches the texture of the work (**8**).

Textures

Colored pencils or colored leads used in mechanical pencils are traditional drawing media. Oil crayons, chalks, or pastels can be used for blocking in color, mixing, and blending. Here we enter the world of painting, with pigments applied directly, worked with the fingers rather than brush. Pastel has as much capacity to represent form and texture as does oil or acrylic paint.

6

7

8

MORE ON THIS TOPIC
· Colored pencils **p. 86**

DRY MEDIA AND WATER

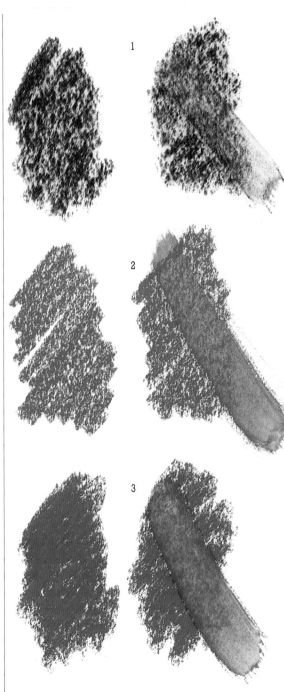

Wet Techniques

Dry media can also be worked with water. Some very interesting effects can be gotten using water, especially when mixing several dry techniques.

For the following samples of water and chalk, a clean, well-saturated paintbrush has been used. The paper is Mi-Teintes, white, using its smoothest side.

Notice the effect a wet brushstroke has when worked into charcoal (**1**). In the wetted area, the intensity of the charcoal diminishes while the charcoal/water mixture gives the white paper the look of having been worked with watercolor.

Next, using sanguine, the effect created is similar (**2**). But the sanguine is far more intense as a pigment. In both examples the addition of brush and water suggests a rich dimension that can be used to great effect.

In the next example a soft sepia pastel has been laid down, then wetted with the brush (**3**).

On the Use of Water

When thick pastel strokes are dampened with a clean paintbrush and water, their hue and structure hold. The area around them is colored with a pale pastel tint or wash (**4**).

By washing over with water on a more uniform and opaque area (**5**) of pastel, rich textures can be created.

If worked with the brush, the pastel strokes can also be modified and given a brushy texture. The introduction of water for use with pastel further extends pastel's potential as an expressive medium (**6**).

The look of watercolor, with its strokes and washes, now becomes a means with which to create volume and texture, while applying the bright opaque pigments of pastel.

4

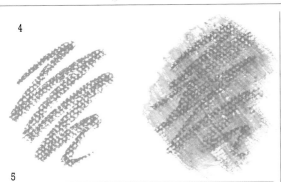

5

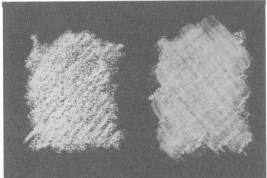

6

MORE ON THIS TOPIC

· Dry and wet media **p. 92**

When alternating wet and dry techniques in one piece of work, it is a good idea to wait until any wet medium dries before applying a layer of dry medium.

Tools

For dry media, pastel or pencils are used for drawing and for blocking in color. For applying water, a paintbrush, sponge, or any other suitable material can be used. The use of each tool has its own look and characteristics.

An inventive composition painted with pastels and water.

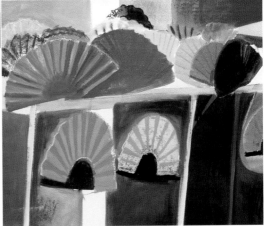

Consider the Support

When using a wet technique over a dry medium you must be sure to paint on a paper or support that can absorb the water.

Whenever you work with water, it is a good idea to tape the paper to a board, on all four sides, so that buckling that occurs while the paper is wet will stretch flat as the paper dries.

DRY AND WET MEDIA

Lines drawn with sanguine Conté crayon over a wash of blue watercolor produce a lovely contrast (**3**). They are drawn when the watercolor is completely dry. The blending of the sanguine reveals the texture of the paper, because of its binder and its intense color, more so than charcoal.

Now, reversing the order, the sanguine is applied first. Two brushstrokes of blue watercolor are painted over the chalk (**4**). The oxides in the sanguine mix with the blue of the watercolor. The resulting color is very evocative. It has the look of a glaze or patina.

Watercolor and Dry Media

Many types of dry media are compatible with watercolor. In example (**1**), charcoal has been used over a completely dry ochre watercolor wash. Notice the effect of blending.

Now, the reverse—a brushstroke of ochre watercolor is applied over a patch of charcoal (**2**). The potential of such mixtures is easy to see. A piece of work carried out using a mixed technique can be very attractive. Here, the charcoal and ochre have a classical feel.

Next, orange pastel is applied over dry blue watercolor paint (**5**). The quality of the blended area demonstrates the way watercolor increases the chalk's adherence to the paper.

Here is a good example of the possibilities of watercolor and pastels. This is simply a brushstroke of watercolor over a few lines of orange pastel, yet the effect is striking (**6**).

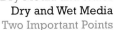

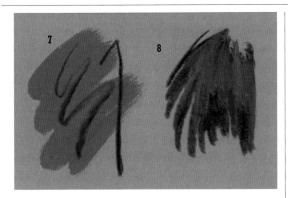

Gouache and Dry Media

Watercolor is a transparent medium. Gouache is known for its opacity. Yet gouache paint can be diluted, making it more transparent and giving it an appearance very similiar to watercolor, though it is always more opaque than watercolor.

Here, crimson gouache has been used to completely cover the paper and create an opaque area. Strokes of charcoal are then laid down over the dried paint, a beautiful effect (**7**).

MORE ON THIS TOPIC
· Dry media and water **p. 90**

Next the crimson gouache has been painted over the charcoal (**8**). The color mixes with the charcoal residue and the brushstrokes are shaded.

Sanguine can be used to draw over dry gouache (**9**). The sanguine retains its chalky properties and is here blended in the circular patch at the bottom.

Crimson gouache brushed over an area of sanguine produces an interesting texture (**10**).

Pink pastel, over a dry gouache patch of red, has a limited blending capacity (**11**). Note the possibility of creating a contrasting texture.

Finally, take a look at these brushstrokes of gouache painted over pastel crosshatching colors (**12**). Notice the texture created with this interaction of lines and brushstrokes.

TWO IMPORTANT POINTS

About the Use of Fixatives

Many artists use fixatives when working with pastels, whereas others prefer not to use them. While a fixative is necessary when working with charcoal, this is not so necessary when working with other dry media, particularly with pastel, although their preservation will then be at risk.

How to Use Them. Fixatives come in two kinds of containers —bottles and aerosol sprays. In order to use fixatives in bottles,

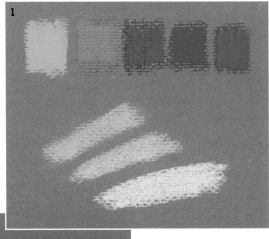

you have to apply them using an atomizer. Aerosol spray fixatives are easier to use.

Whichever product you are using, the fixative must be applied in thin, even layers. The drawing should be sprayed with fixative using a circular or zigzag movement from approximately 3 to 4 inches.

There are several types of fixatives. The best one for dry media is the non-gloss type, as this better preserves the powdery surface of pastel.

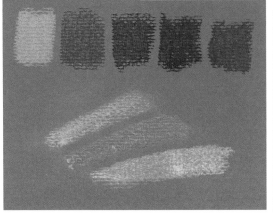

The size of the board is greater than that of the paper.

Disadvantages of Fixatives.
Only a thin, even layer will prevent puddling or patches of lacquer saturation. These occur when fixative accumulates on the surface of your work. These patches can change the look of your painting. For this reason some artists prefer not to use fixative on the final layer of a drawing.

Advantages of Fixatives.
Fixatives increase the capacity of the paper to hold the pastel. Heavy coloring will finally saturate the surface with chalk. In this case, however much you overlay color, the pastel will not adhere. A spraying of fixative will enable reworking, so that the piece can be finished.

Color can also be fixed so that overlaid colors do not mix. Look at the differences between the examples. In (**3**), a fixative has not been used and the colors blend. In (**4**), the green lines have been fixed. The pink has been worked over them. The blending is minimal and the green lines retain their integrity.

Some artists use fixative as a medium to allow the chalk to be worked in layers. Others use fixatives to preserve the pastel. Fixative reduces the brightness of the colors. To fix or not to fix is the artist's perpetual dilemma. Observe the results after fixing several colors. In (**1**), the colors have been applied without fixative, and in (**2**), a layer of fixative has been added.

MORE ON THIS TOPIC
· Dry media **p. 12**

Helpful Hints

Dry media tend to shed their colors. Pastel sticks are colored by proximity with other pastels, as well as by handling. It is a good idea to keep a scrap of paper on hand in order to try out colors before you use them on your work, as the surface of the stick may be coated with other pigments. When pastels are stored in containers of uncooked rice, this keeps them somewhat cleaner. They may also be cleaned with a rag.

Because so much of pastel is worked with the fingers, using a cotton rag to keep them clean is helpful when shifting color ranges.

A cardboard frame to protect areas not being worked can be helpful when blending. The hands can be protected with artist's creams, sold in the art supply store. Pastel can be washed from the skin with soap, water, and a scrub brush, if needed.

A drawing board, with a clip, that is larger than your paper provides a good work surface for pastel paper.

Cleaning one's fingers.

Cleaning the pastel.

Original title of the book in Spanish:
Mezcla de Colores 3. Técnicas Secas
© Copyright Parramón Ediciones, S.A. 1999—World Rights.
Published by Parramón Ediciones, S.A., Barcelona, Spain.
Author: Parramón's Editorial Team
Illustrators: Parramón's Editorial Team

Copyright of the English edition © 2000 by
Barron's Educational Series, Inc.

All inquiries should be addressed to:
Barron's Educational Series, Inc.
250 Wireless Boulevard
Hauppauge, New York 11788
http://www.barronseduc.com

International Standard Book No. 0-7641-5227-0

Library of Congress Catalog Card No. 99-65089

Printed in Spain
9 8 7 6 5 4 3 2 1

Note: The titles that appear at the top of the
pages correspond to:

The previous chapter
The current chapter
The following chapter